HOW TO DRAW WITH A
BALLPOINT PEN

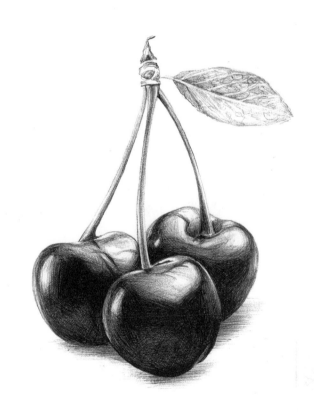

Quarto is the authority on a wide range of topics.

Quarto educates, entertains and enriches the lives of our readers—enthusiasts and lovers of hands-on living.

www.QuartoKnows.com

Translation © 2017 Quarto Publishing Group USA Inc.
The original German edition was published as Kuli Kunst.

Copyright © 2016 frechverlag GmbH, Stuttgart, Germany (www.frechverlag.de)

This edition is published by arrangement with Claudia Böhme Rights & Literary Agency, Hannover, Germany (www.agency-boehme.com).

First published in the United States of America in 2017 by
Quarry Books, an imprint of
Quarto Publishing Group USA Inc.
100 Cummings Center
Suite 406-L
Beverly, Massachusetts 01915-6101
Telephone: (978) 282-9590
Fax: (978) 283-2742
QuartoKnows.com
Visit our blogs at QuartoKnows.com

10 9 8 7 6 5 4 3 2 1

ISBN: 978-1-63159-317-8

Cover and Book Design: Katrin Röhlig
Cover Image: Gecko Keck
Photography: Gerhard Wörner
Illustration: Gecko Keck

Printed in China

FSC
www.fsc.org

MIX
Paper from
responsible sources
FSC® C104723

HOW TO DRAW WITH A
BALLPOINT PEN

Sketching Instruction, Creativity Starters,
and Fantastic Things to Draw

GECKO KECK

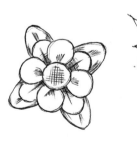

Foreword

Simple but ingenious. On the tip of a fine, ink-filled tube rotates a tiny ball that, while writing or drawing, transfers color to a surface. Starting out with ideas that date back to Galileo Galilei and brought to perfection by Hungarian László József Bíró, the ballpoint pen set out on a triumphal procession around the whole world, a success story which has not yet come to an end.

Sometimes while drawing at night, I stared out the window lost in thought, looking for new ideas. At those moments, our earth appeared to me to be just like a tiny ball rotating in the infinite black-blue expanse of the universe. With that crazy comparison in mind, I started to anticipate that there are more possibilities for a ballpoint pen than just taking quick notes or filling in forms. Could it be that even worlds of art and unknown creative scopes of design are hidden beneath the tiny ball?

My answer to this question is in this book, which is a collection of drawings from many weeks and months. If you would like, start your own work right away, draw along, or get inspired by the various approaches presented. This is not only an instruction book. While flipping through, it should help you look at the ballpoint pen as a creative tool and awaken the desire to start using it.

Have fun reading and drawing.

Yours, Gecko

Contents

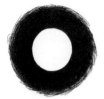

A First Stress Test
Page 10

Few Lines with Big Impact
Page 12

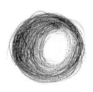

Areas and Gradations
Page 14

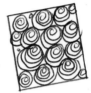

Patchwork–An Artistic
Ballpoint Pen Carpet
Page 16

The Magical Circle
Page 18

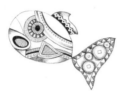

In the Depths of the Ocean
Page 20

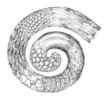

The Spiral of Materials
Page 22

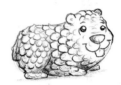

My Hamster Is a Chameleon
Page 24

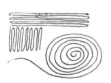

In the Labyrinth of Lines
Page 26

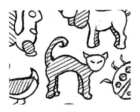

Pictogram, Wherever the
Eye Looks
Page 28

Upside Down World
Page 30

Flower Magic
Page 32

On the Tracks of
Abstract Art
Page 36

Microcosms
Page 38

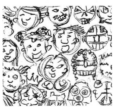

The Micro-Insanity Goes On
Page 42

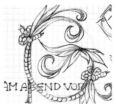

Typography
Page 46

Dropped Capital
Page 48

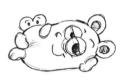

Comics, the First Steps
Page 52

Comics, the Next Steps
Page 54

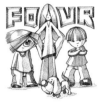

Comics, Artwork and
Style Variations
Page 56

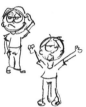

My Life Is a Comic!
Page 58

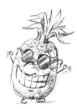

Surreal Worlds
Page 62

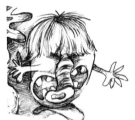

Attack of the Dust Mites
Page 64

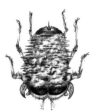

Other Surreal Techniques
and Fantasy Worlds
Page 66

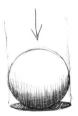

A Small Technical Slide-In
Page 72

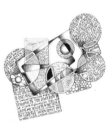

An Abstract Diary
Page 74

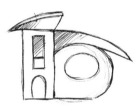

Modern Dream Homes
Page 76

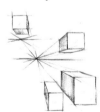

Perspective…or Not?
Page 78

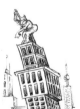

Everything Cubic
Page 80

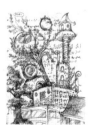

A Ruin Becomes a
Fantasy Palace
Page 82

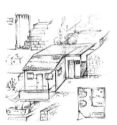

Sketch a Project
Page 84

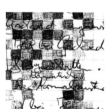

Pixelized Pixels
Page 86

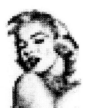

Pixel Art Meets
Hollywood Icons
Page 88

Crazy Collages
Page 90

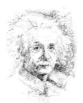

Scribbly
Page 92

Back to Innocence
Page 100

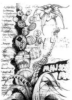

Scraps of Paper
Page 104

Message for a Successor
to the Throne
Page 108

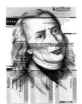

Lasting Memories
Page 110

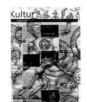

The Culture Machinery
Page 112

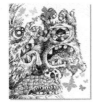

Monsters Hunt Butterflies
Page 114

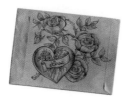

When the Mailman Rings...
Page 116

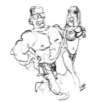

Observing and Caricature
Page 120

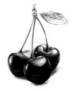

Photorealism
Page 122

Levels of Difficulty

 This is simple

 You can do it

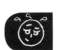 This is hard

Tool Test

All of This Is Possible with a Ballpoint Pen.

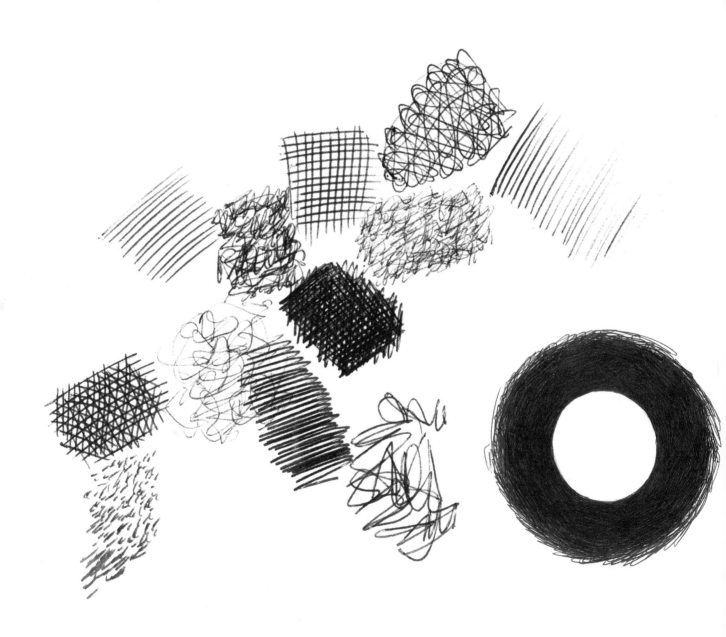

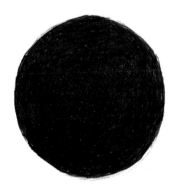

The first test already features an
abstract ballpoint pen picture.

A First Stress Test

Who hasn't doodled, written, or drawn with a ballpoint pen? Ballpoint pens are found everywhere—in every office, every household, and even at schools.

But what else can you do with these pens other than fill out forms or write down notes? First, let's subject pen and paper to a small stress test.

Apply the ink to the paper as thick as possible by drawing lines that get denser. The paper will start to curl, maybe even threaten to rip, but it will achieve an interesting gloss.

Finally, closed areas will emerge, but irregularities in the color application remain, as you can see in the picture on the left.

Few Lines with Big Impact

A few small drawing exercises in the beginning will teach you skills for later. Various forms of lines, parallel shading, cross-hatching, doodle shading, and gradients from a dark-pen blue to the white of the paper. Everything can be tested.

Various forms of lines

Wide and dense

Fast and curved

Thin and dashed

Doodled

Interrupted

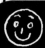

Cross-hatching: For this, too,
all lines are drawn parallel.
For finer gradations, draw more
on top of the first lines going
in the other direction.

Doodle shading: A line
mesh created by doodling
random lines.

Parallel shading: All
lines run parallel.

Shading techniques

Areas and Gradations

You can draw color gradients surprisingly well with a ballpoint pen. There are two ways to do so: One is a fast, sketchy progression, and the other is a subtle, fine gradation. This page shows both possibilities.

Wide gradation

Dense gradation

Dashed gradation

Dotty gradation

These first illustrations show fast, sketched gradients from blue to white using lines, interrupted lines, and dots.

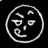

Fine Gradients and Shading Techniques

These illustrations show very fine gradations. For this effect, you must hold the ballpoint pen very straight and draw very fast—especially for the light shading.

Lots of pressure →→→→→ Little pressure

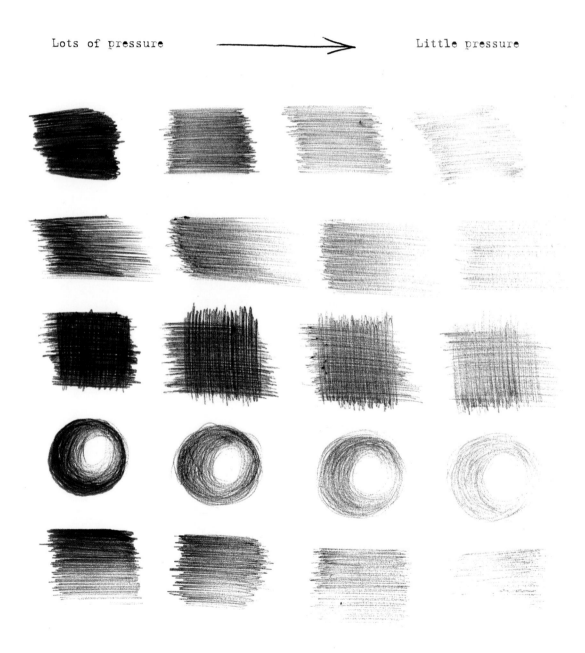

Patchwork—An Artistic Ballpoint Pen Carpet

The first lines alone can be combined creatively into an interesting picture. The patchwork on page 17 consists of various technical finger exercises and evolved into an abstract composition.

Some squares resemble materials such as stone, brick, tile, and cotton.

Step 1:
Draw a square.

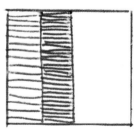

Step 2:
Draw your first lines.

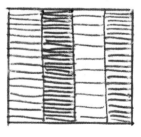

Step 3:
Develop a structure using the lines.

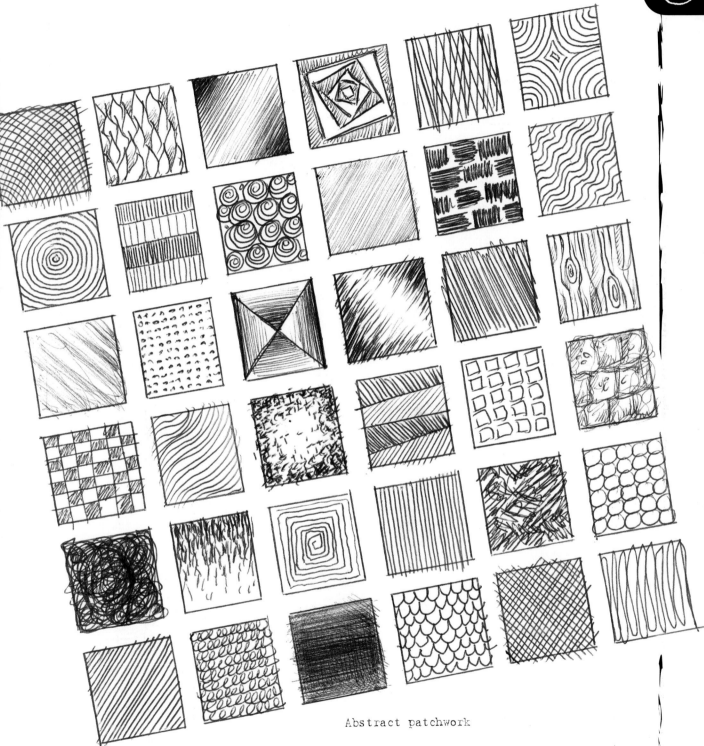

Abstract patchwork

The Magical Circle

Circles are the starting point for many designs. That's why outlining clean circles in all sizes is a type of "drawing gymnastics" you can use to loosen up. With the help of the shading techniques shown on page 15, the simple circle (top left on this page and the next) becomes a ball.

In the following variations, you'll find many new creative experiences once again; for example, abstract, modified circles; circles that become graphic stylized faces; circles with gears; and pizza slices.

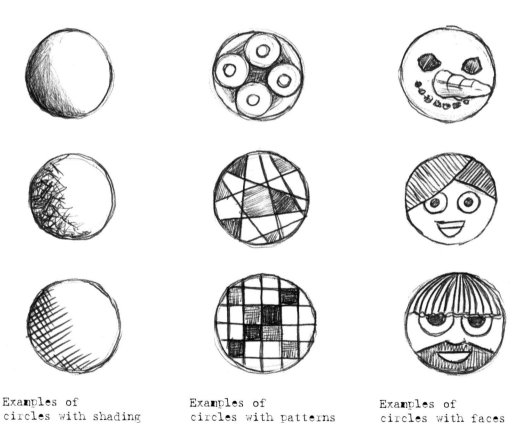

Examples of
circles with shading

Examples of
circles with patterns

Examples of
circles with faces

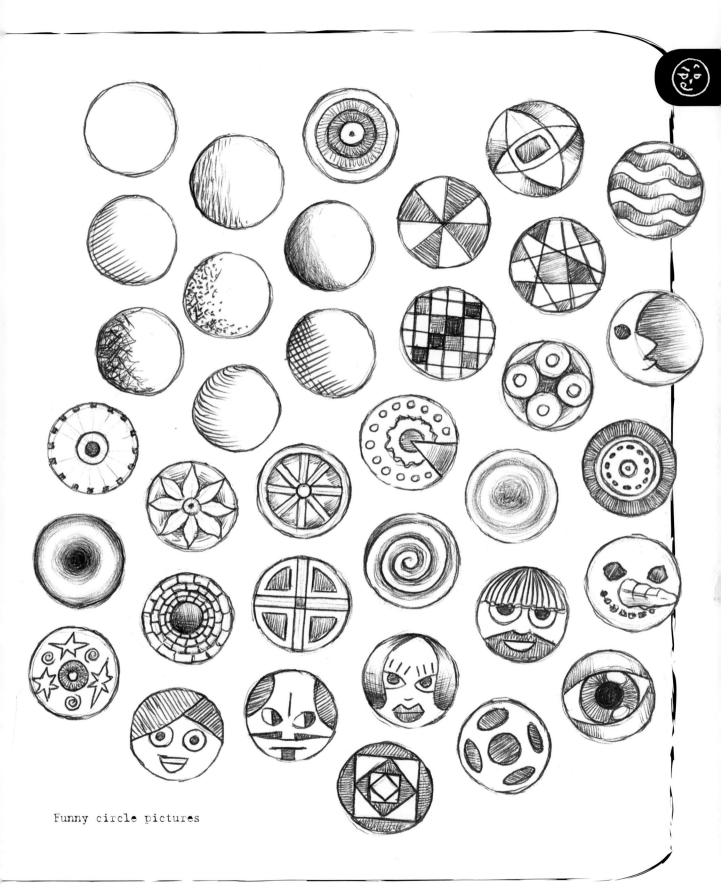

Funny circle pictures

In the Depths of the Ocean

The things you've learned so far offer an amazing variety of design possibilities. Here is another really basic form example—a fish. These shapes are great areas for abstract patterns and ornamental forms. New sea worlds with imaginative creatures emerge. The more you let go of things from nature, the more interesting it becomes.

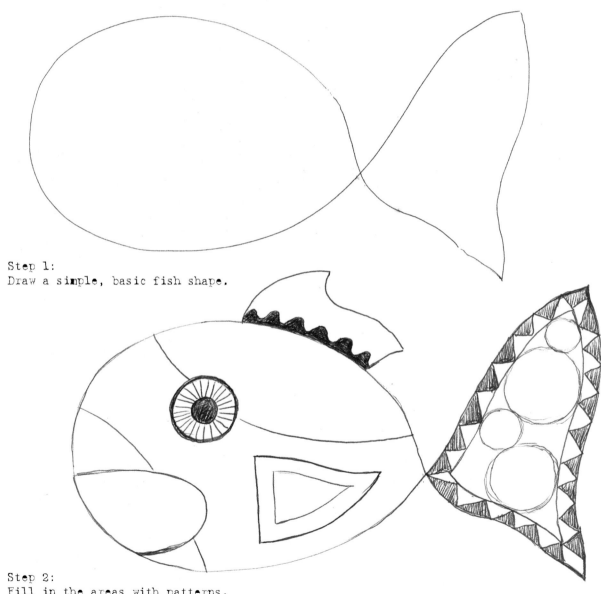

Step 1:
Draw a simple, basic fish shape.

Step 2:
Fill in the areas with patterns.

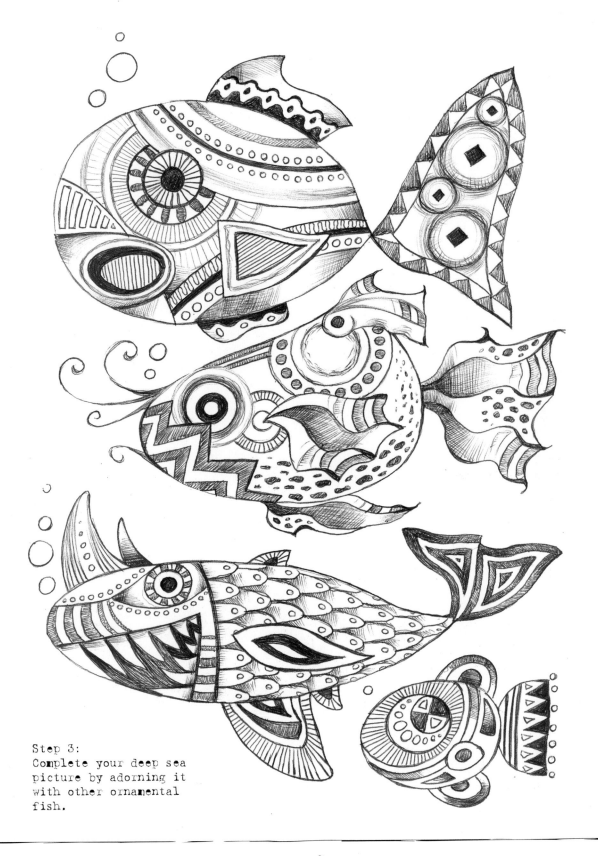

Step 3:
Complete your deep sea
picture by adorning it
with other ornamental
fish.

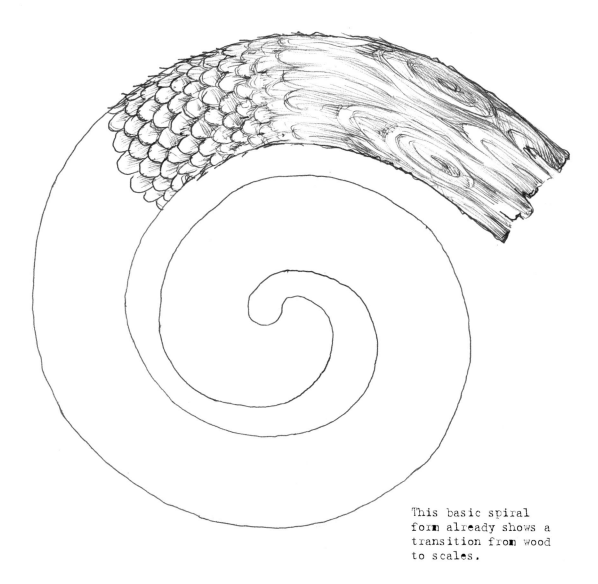

This basic spiral
form already shows a
transition from wood
to scales.

The Spiral of Materials

The depiction of materials and structures, such as wood, stone, fur, or feathers, is fundamental to creating complex and realistic illustrations. The spiral is perfect for practicing these structures, and anybody who dares can try to draw fluent transitions from one texture to the next.

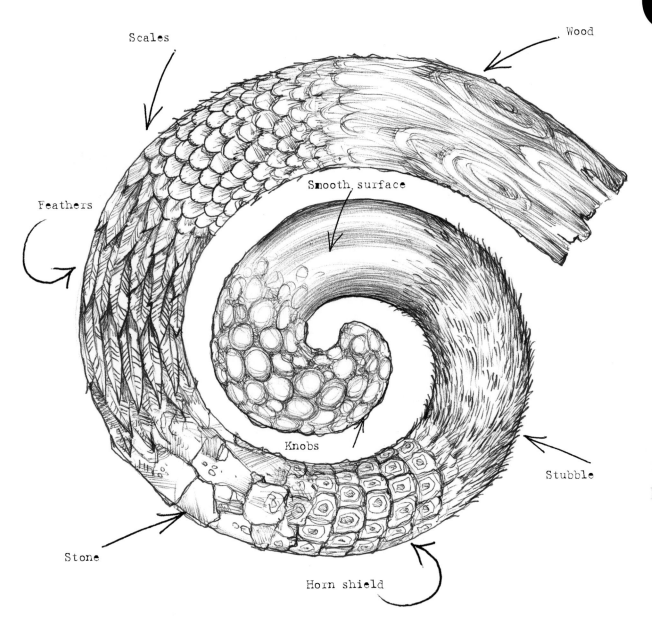

Scales

Wood

Feathers

Smooth surface

Knobs

Stone

Stubble

Horn shield

If the textures are drawn well,
it almost seems as if you could
feel the textures.

My Hamster Is a Chameleon

Following the free-form drawing, patterns, and first material tests, we're getting a bit more specific now. An even better way to test out different surfaces can be done with the help of a cute animal. Simply draw the outline of a small animal multiple times and then draw the textures (e.g., hair, bristles, folds, or feathers).

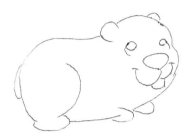

Step 1:
With a few lines, sketch a hamster.

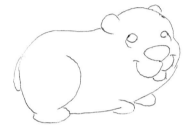

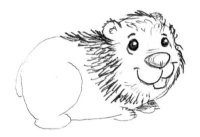

Step 2:
Shape the surface.

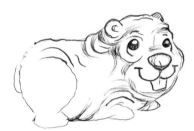

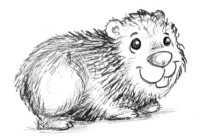

Step 3:
Fill the entire surface with the desired texture.

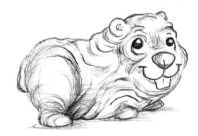

Short-hair hamster

Pudgy hamster

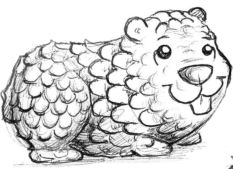

Scaly hamster

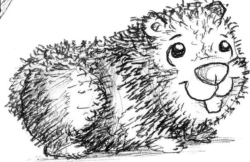

Bristle hamster

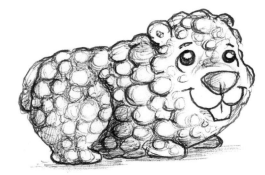

Knob hamster

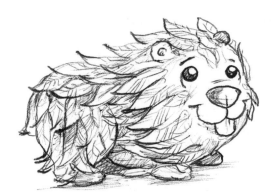

Feathered hamster

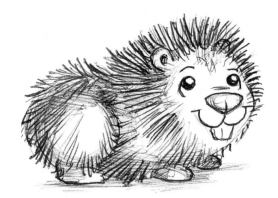

Hedgehog hamster

Different kinds of skin and
fur make the animal appear new
every time and even surreal in
some instances.

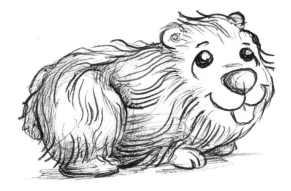

Long-hair hamster

In the Labyrinth of Lines

If you would like to become more confident in your line drawing, the following exercise is useful. Drawing various line structures and a narrow labyrinth require high concentration because no line is supposed to touch another.

Similar to the Patchwork section on page 17, abstract image compositions emerge.

Tight labyrinth

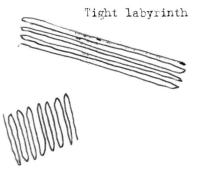

Wide, rounded labyrinth

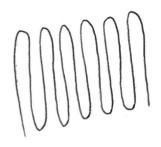

Round labyrinth

Note the differences between tight and wide ballpoint pen labyrinths, round and angular, as well as big and small ones.

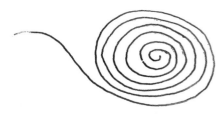

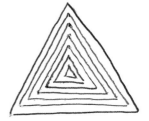

Triangle labyrinth

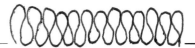

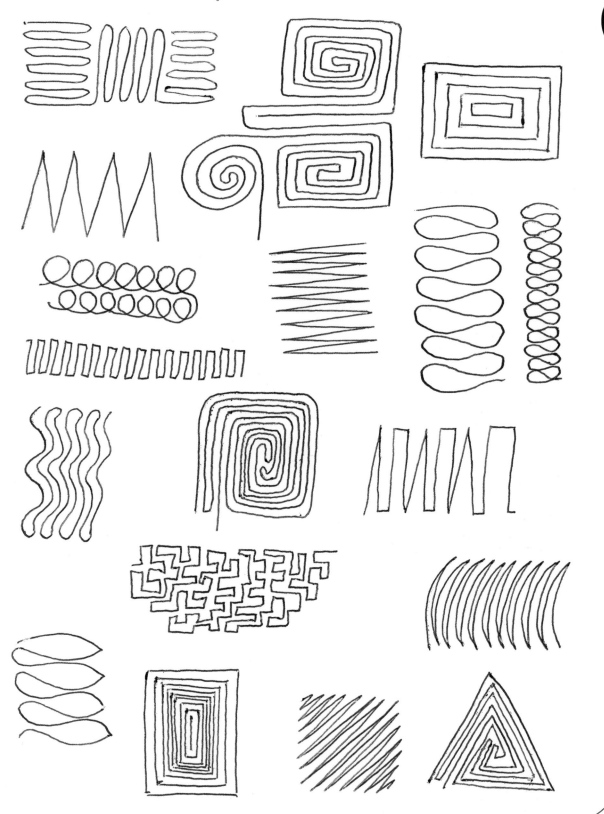

Pictogram, Wherever the Eye Looks

Few designs reflect the spirit of the times like small symbols, pictograms, icons, or buttons. Be it in the digital world, at school, or at work, your computer, tablet, and smartphone screens are filled with tiny pictures. It is fun to draw big things as small as possible. At the same time, it is quite the art to be able to draw entire worlds within the size of a stamp or even smaller.

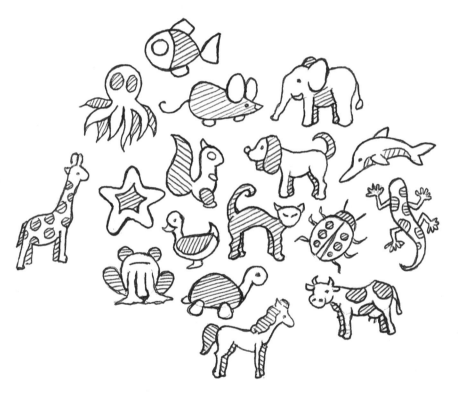

Small animals are especially well-suited for versatile usage on invitations, in school notebooks, in presentations, and much more.

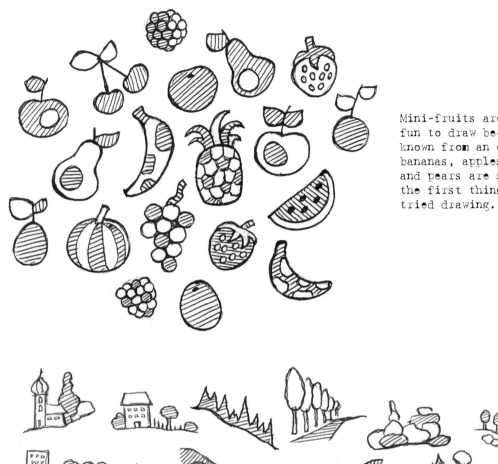

Mini-fruits are especially
fun to draw because they're
known from an early age—
bananas, apples, cherries,
and pears are some of
the first things we
tried drawing.

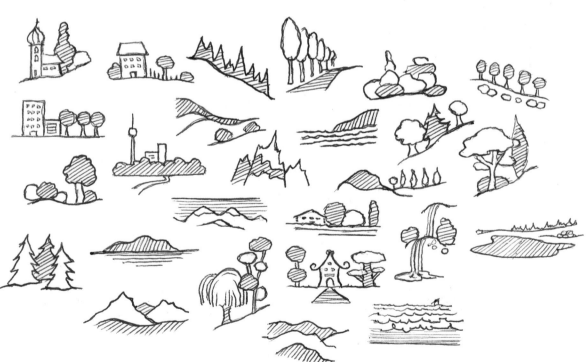

Even different landscapes can be depicted in a mini
format, from hill, forest, and mountain landscapes
to city and village landscapes.

Upside Down World

First draw basic shapes of different things, for example, bottles, balloons, or cars. Then get inspired by the initial shapes and turn them into something completely different, such as this freak parade.

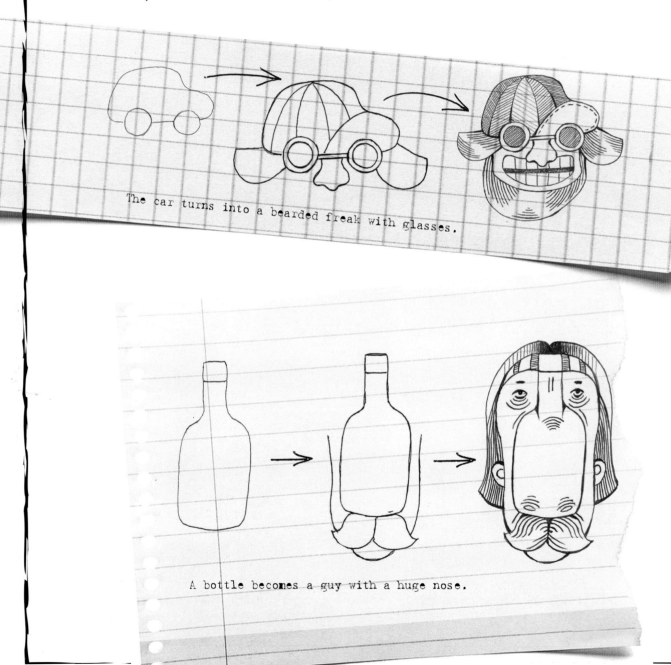

The car turns into a bearded freak with glasses.

A bottle becomes a guy with a huge nose.

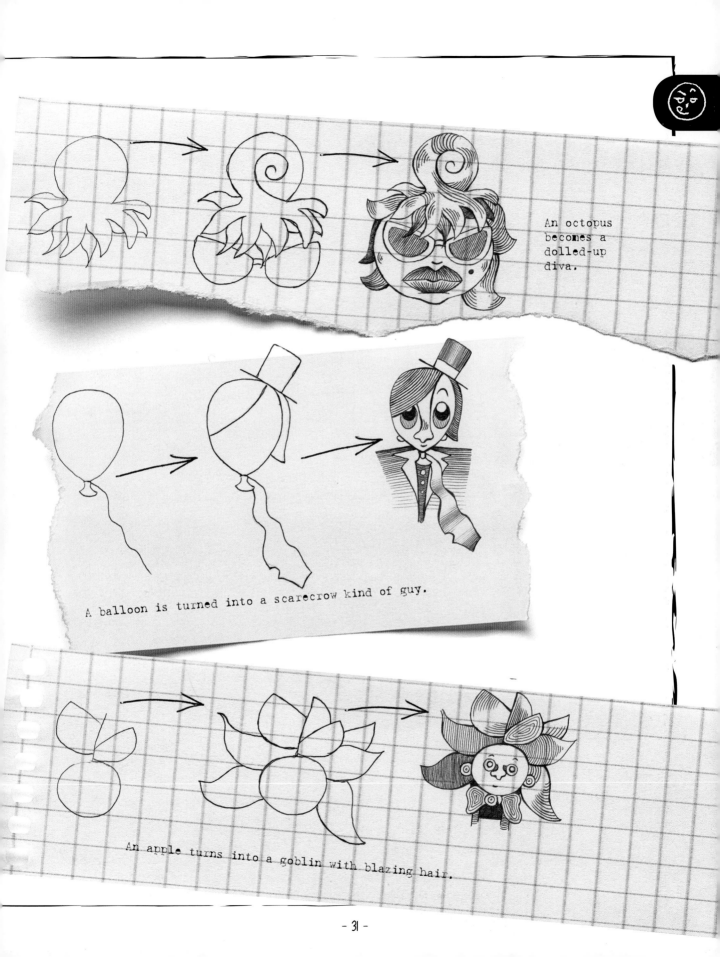

An octopus
becomes a
dolled-up
diva.

A balloon is turned into a scarecrow kind of guy.

An apple turns into a goblin with blazing hair.

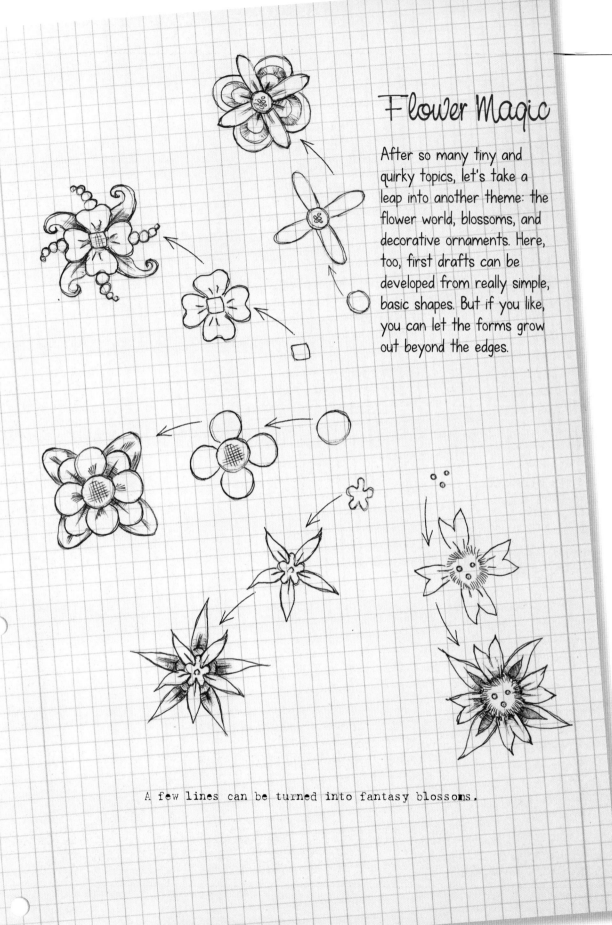

Flower Magic

After so many tiny and quirky topics, let's take a leap into another theme: the flower world, blossoms, and decorative ornaments. Here, too, first drafts can be developed from really simple, basic shapes. But if you like, you can let the forms grow out beyond the edges.

A few lines can be turned into fantasy blossoms.

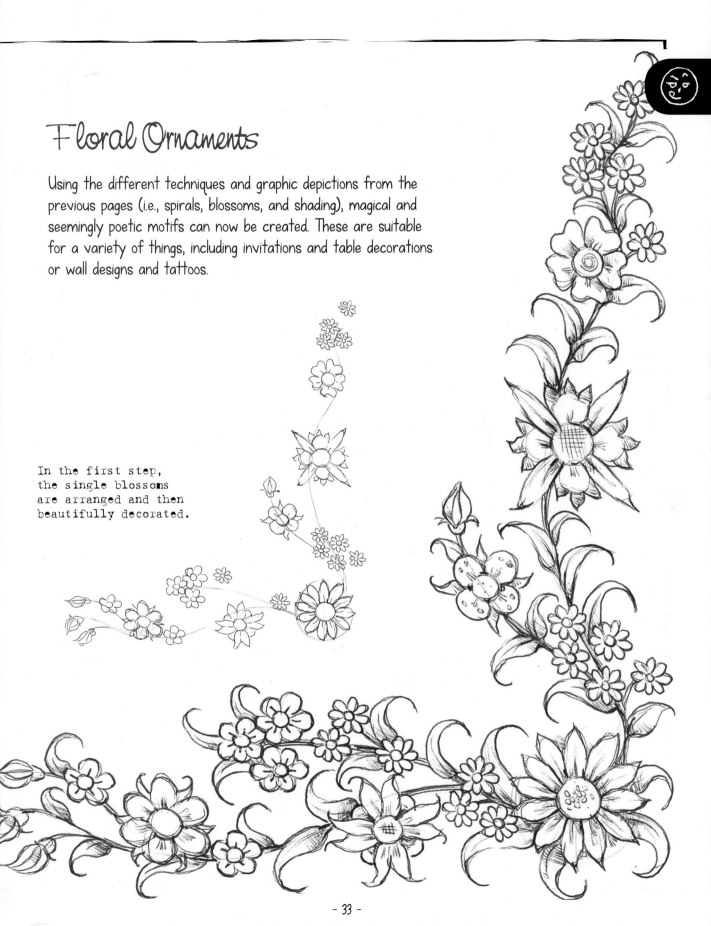

Floral Ornaments

Using the different techniques and graphic depictions from the previous pages (i.e., spirals, blossoms, and shading), magical and seemingly poetic motifs can now be created. These are suitable for a variety of things, including invitations and table decorations or wall designs and tattoos.

In the first step, the single blossoms are arranged and then beautifully decorated.

Graphic Floral Ornaments

In contrast to the flower ornaments on pages 32-33, these ornaments are created graphically, which means they consist of spirals and simple leaf forms. From a technical standpoint, these lines are more controlled and drawn slower. These kinds of motifs are great for illustrating books.

Simple structures with outgrowing spirals from one strand

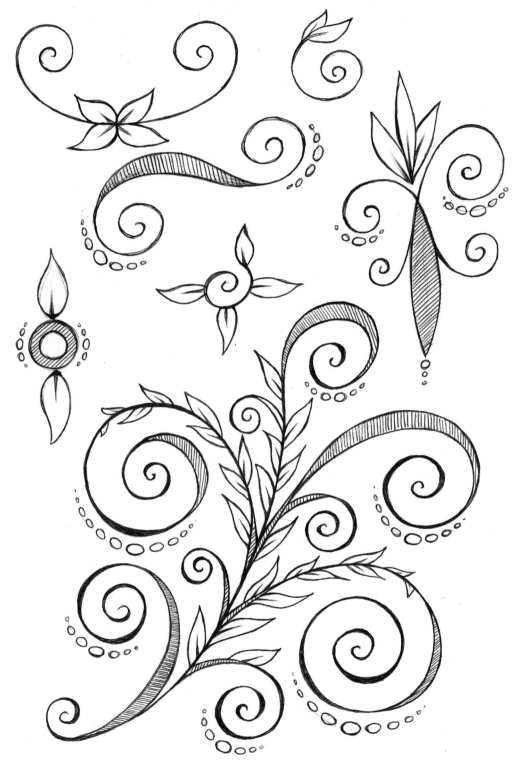

Finished graphic floral ornaments

On the Tracks of Abstract Art

To promote creativity further, we'll take another big leap—this time
into abstract art. Because what looks simple is, in reality, one of the
hardest things to accomplish—a completely nonrepresentational drawing.
A quickly and randomly doodled web of lines creates your starting point.
This doodle can be turned into an abstract drawing by using all of the
previously shown graphic techniques.

In a close up detail, it is
easier to see how the areas
are filled in.

The web of lines should start
out as random as possible.
If it seems difficult, simply
close your eyes while drawing.

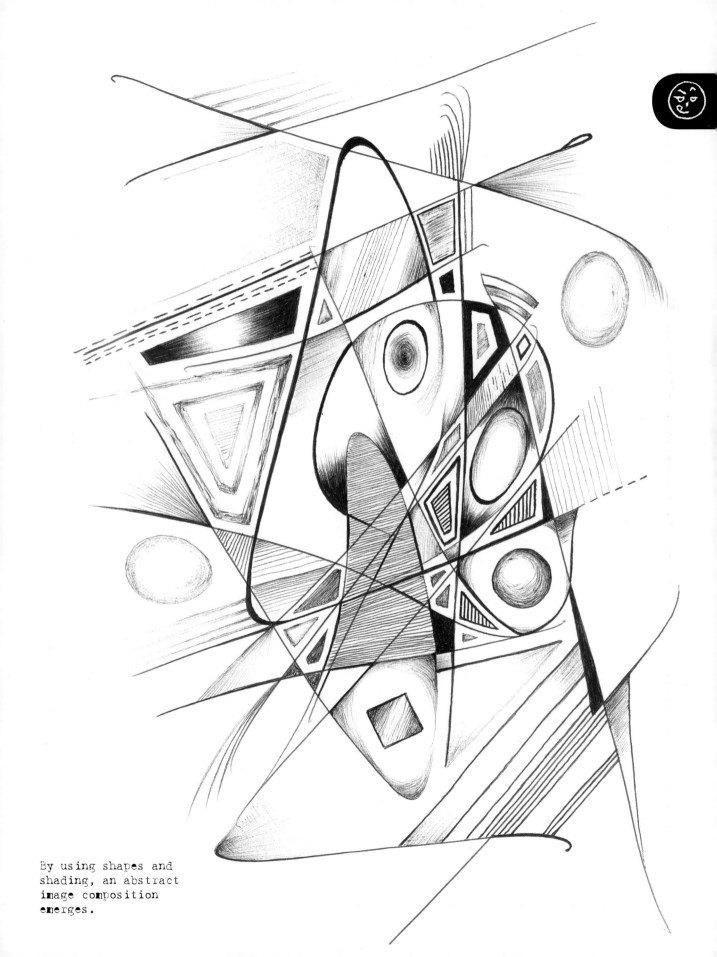

By using shapes and
shading, an abstract
image composition
emerges.

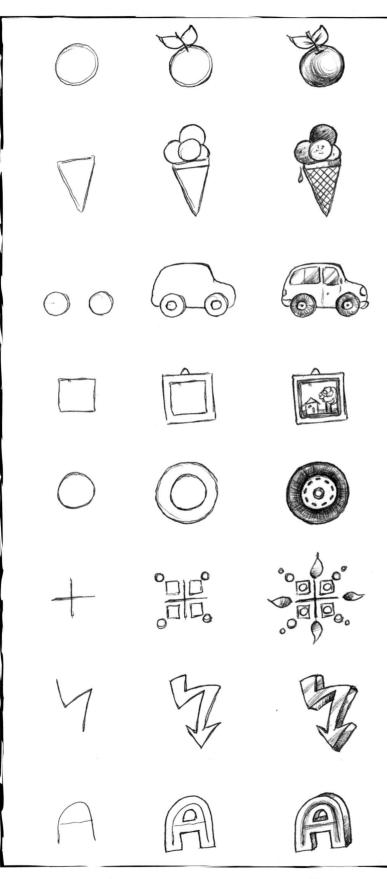

Microcosms

Let's come back up from a dive into the world of the abstract and jump right into miniature graphics and microcosms. Pictograms accompany everyday life nonstop—be it on packaging, technical devices, or in the media. Pictograms offer instructions, help, and orientation. But can they be turned into art? On these pages, you'll see how small pictogram images are created in a few steps with fine shading and small details.

On pages 40-41, you'll find a whole pictogram carpet, partially drawn with a red ballpoint pen to make it a bit more diverse.

Mini-pictures in steps

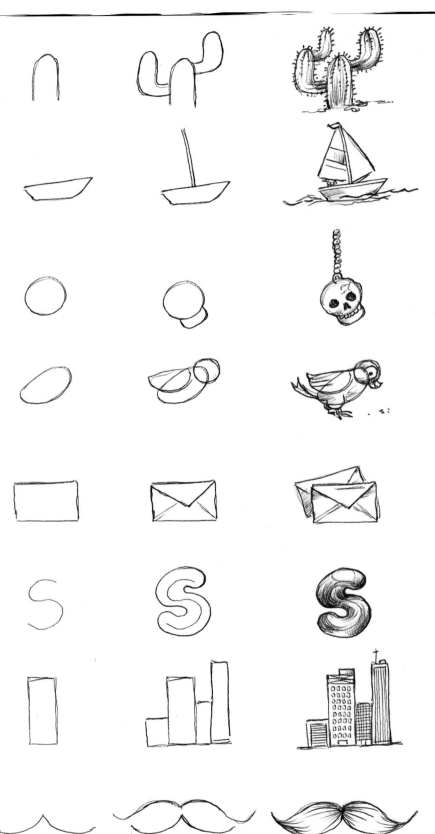

In the first step, a really simple shape or line is recognizable without any connection to an object. In the second step, however, you realize what it will be after only two or three lines have been added. In the third step, you'll discover the finished image.

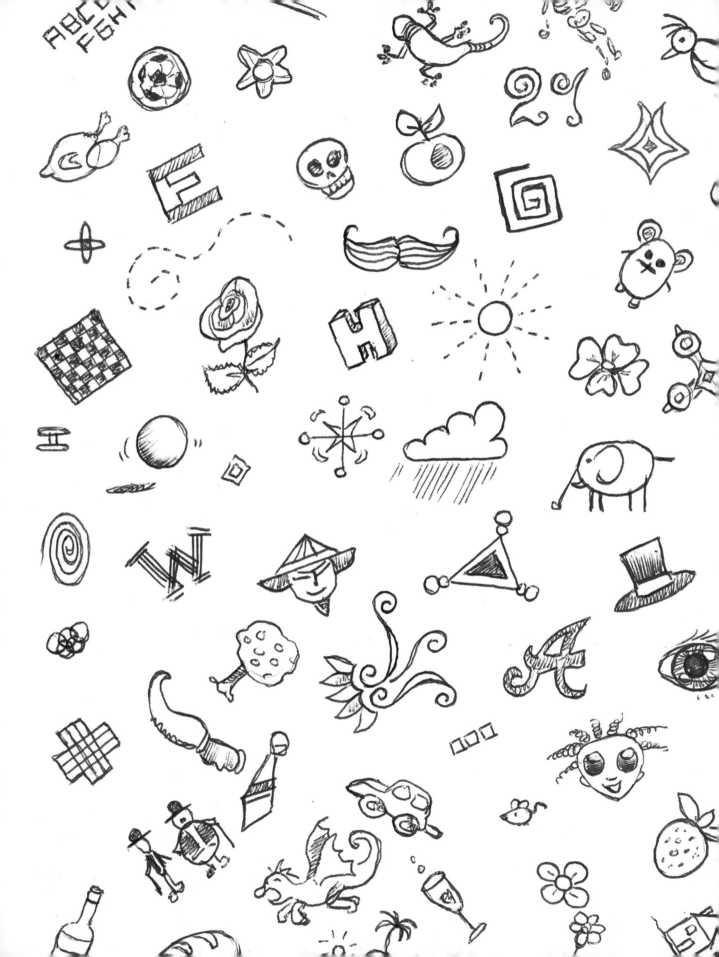

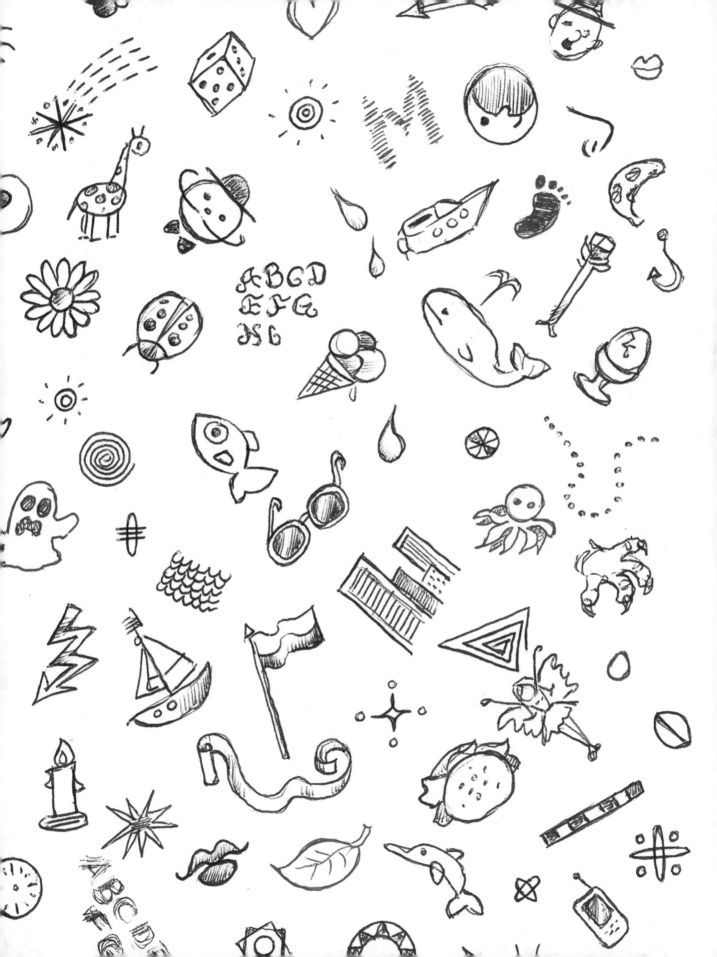

The Micro-Insanity Goes On

The illustrations on pages 42-45 are very time-consuming, the progress is very slow, and they require a lot of concentration. What insanity took hold of me when I started these drawings? Well, as it is most often, insanity comes step by step. My first thought was to continue with the circles from page 19 and create countless mini-faces. Then I decided to turn it into an area, which appears uniform at first glance. Although, in reality, no two faces or masks are alike.

Looking at it from a creative point of view, such an illustration is an excellent performance test because you'll need hundreds of different design ideas in a small format.

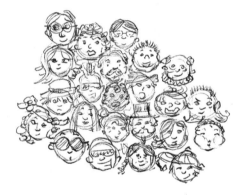

First faces emerge.

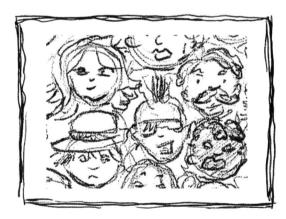

The details reveal the variety of faces.

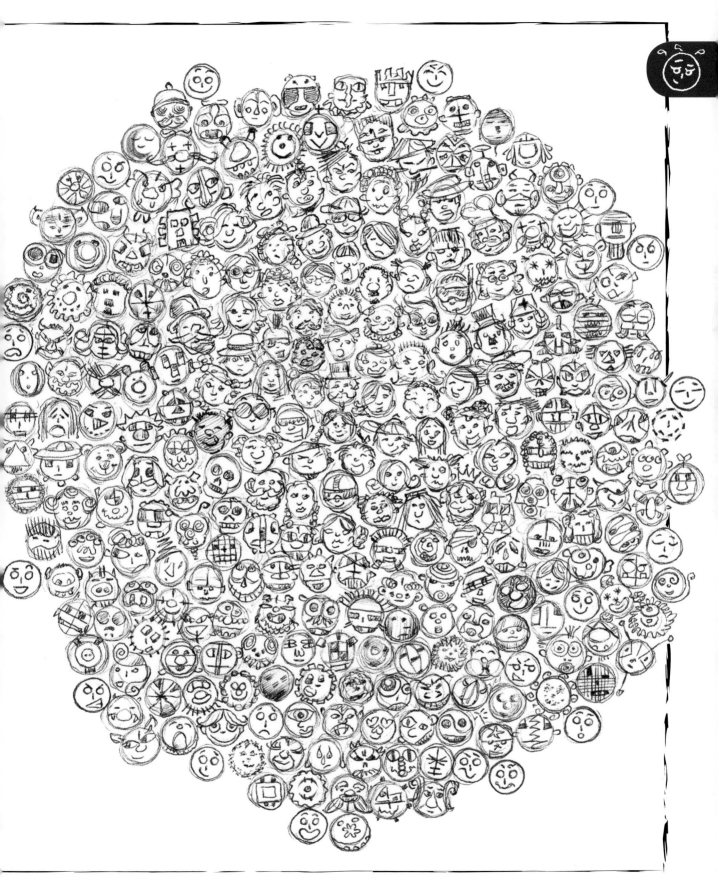

Of the three variations, the most complicated one is the animal jumble. No mark is coincidental, even if it does appear that way. Every line, no matter how small, is part of an animal. This illustration is placed vertically on purpose so all of the animal insanity is better visible.

Animal insanity

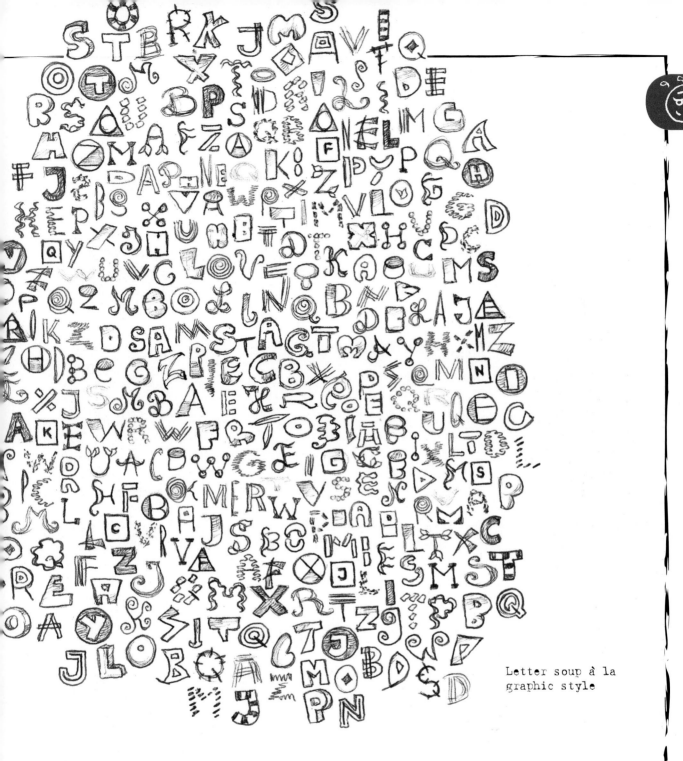

Letter soup à la
graphic style

For this variation, the basic idea is built on letters. New ideas for
letterforms are constantly needed. You can drive the viewer even
crazier by adding small messages (shown in red) into the vast mix
of letters.

Typography

Let's turn toward a very different theme: fonts. The art of typography has centuries-long traditions. It goes back to the earliest human history, in the Middle Ages with the invention of the letterpress through Gutenberg, and typography reaches new heights today with digital images and text editing that make the possibilities even greater.

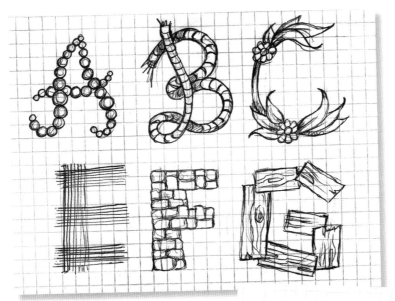

Designed letters made up of various materials

Why not create your own fonts? Graph paper is a big help because the lines can be used for orientation.

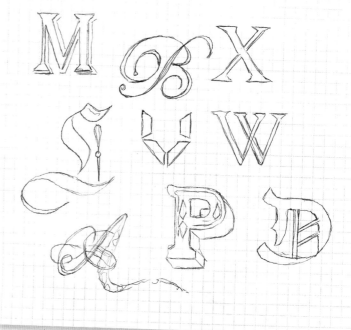

Different computer fonts redrawn

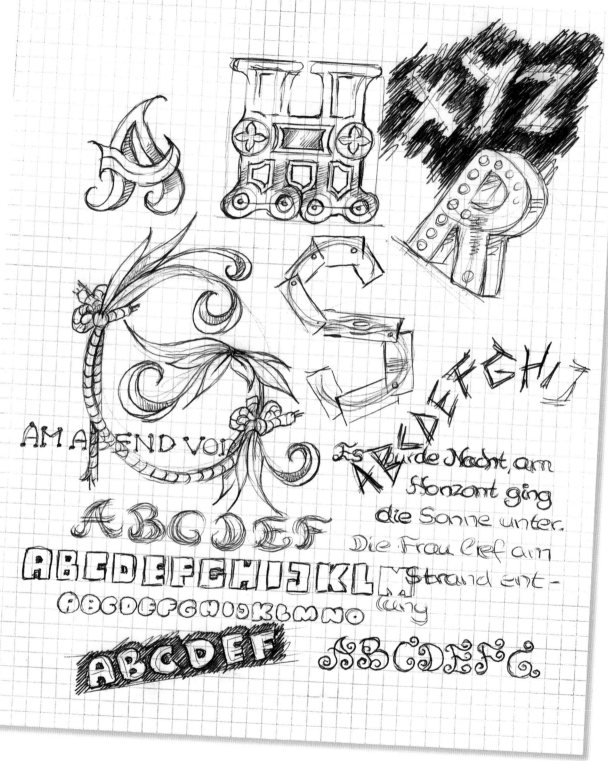

Letters in various styles and different sizes—time to experiment

Dropped Capital

A dropped capital is the first letter of a text, such as books, magazines, or digital media, that is made bigger or bolder than the rest. Back in the days when books were still copied by hand, like in the Middle Ages, these ornamental first letters were often very artistic and spread across whole pages. Dropped capitals are still around today—especially in the fantasy genre, which is really fitting, because these letters are great for fantasy creations. There are no limits to the scope of design.

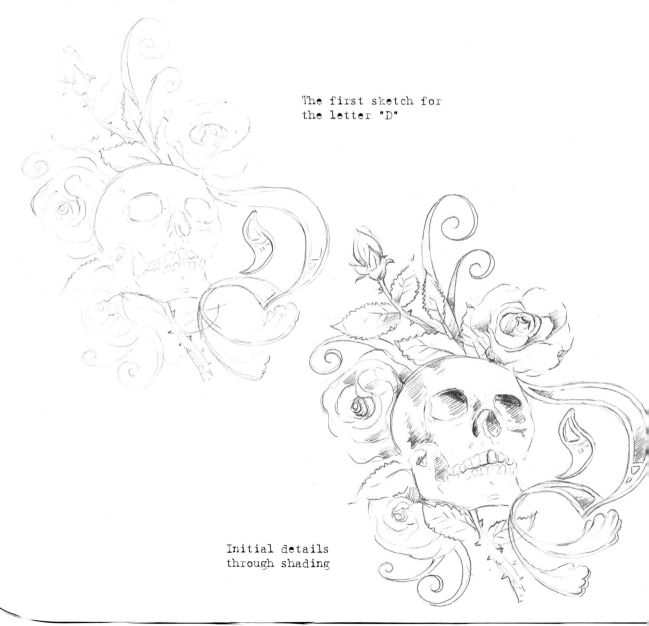

The first sketch for
the letter "D"

Initial details
through shading

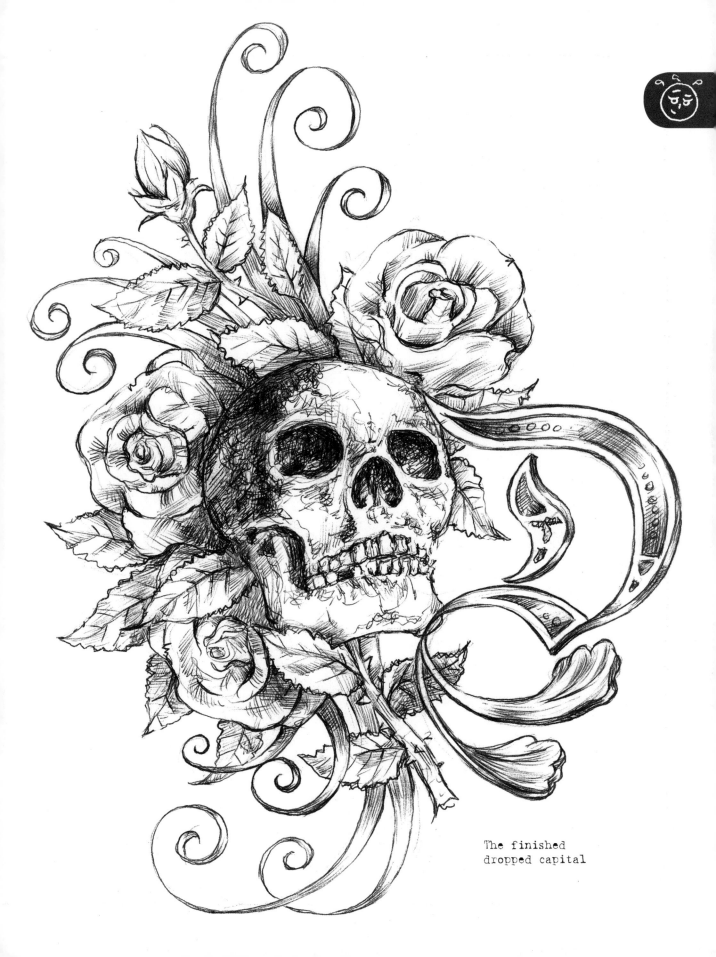

The finished
dropped capital

Comics and More

What Else Can a Ballpoint Pen Do?

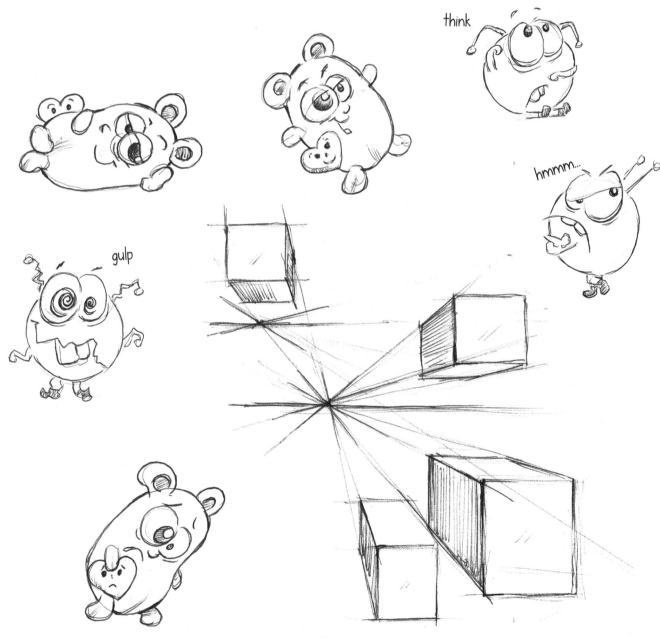

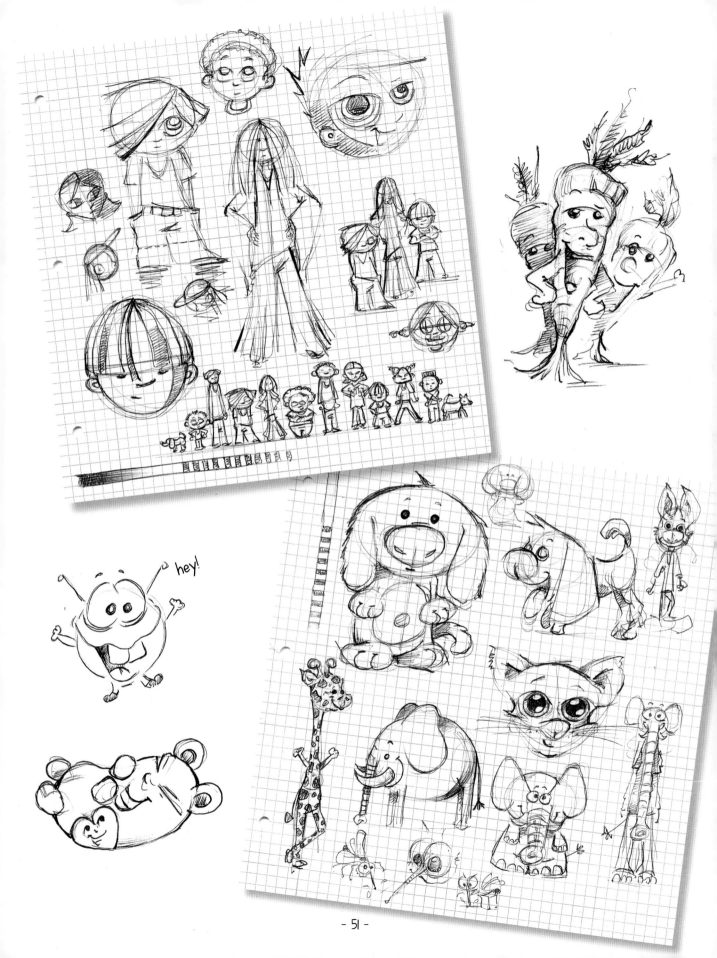

hey!

Comics, the First Steps

Drawing comics is its own form of art. It has long been underestimated, but today, comics are everywhere, be it on television, in digital media, or in printed form. Getting into drawing comics is not that hard if you start with simple shapes. Circles and ovals, for example, make good bases for figures. Afterwards, you can try to animate the comic character and draw funny, lively faces.

This crazy head-footer started out with a simple circle.

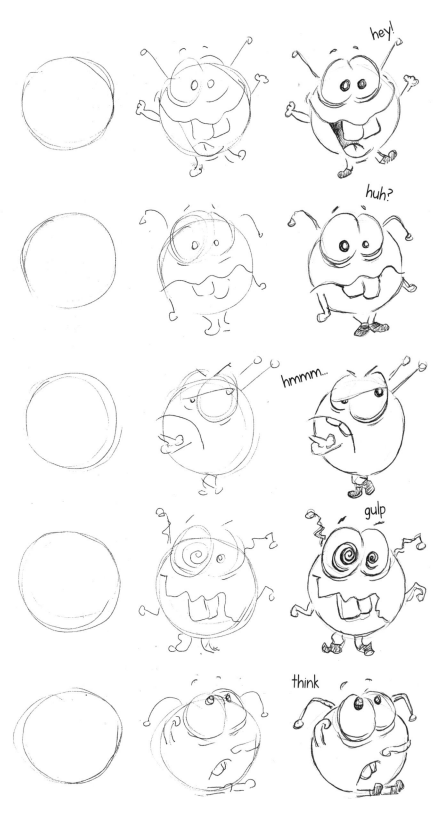

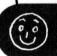

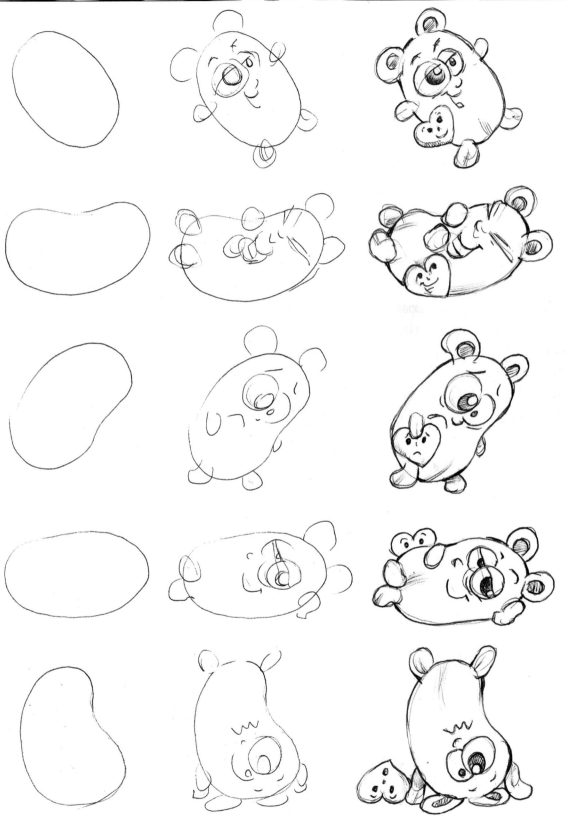

This mouse started out as an oval.

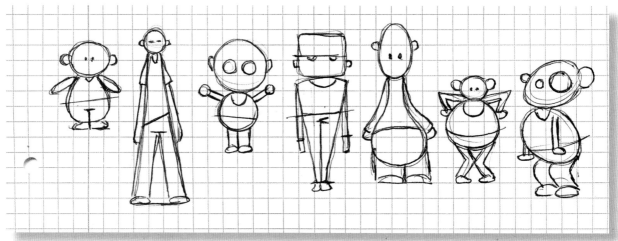

Just like a building set, funny guys can be created with simple geometric shapes.

In the next steps, the gang can be refined and details are added.

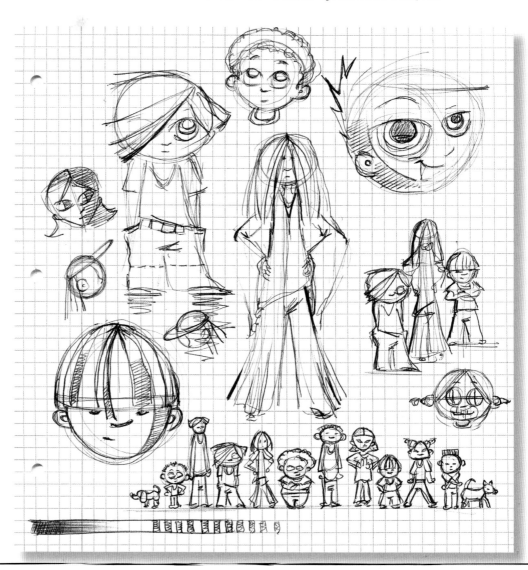

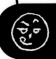

Comics, the Next Steps

This is just like being back at school! Boring classes and the notebook is already being used for other things—things that are more fun. Graph paper is really great for drawing comics, because it is easier to read the proportions of a figure and easier to transpose the design into other poses.

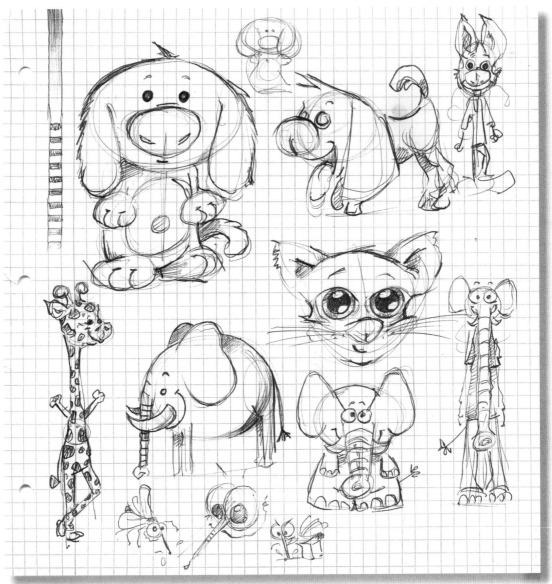

The three elephants in this collage clearly show how different the design of one character can be.

Detailed comic picture, cleaned up and finalized

Comics, Artwork and Style Variations

A comic image is finalized. Starting out with the sketch and a ballpoint pen, fine artwork is created as the comic subject is drawn, cleaned up, and finalized. To do so, all techniques shown until this point can be used. You can also add a name to the figures. These two boys, the tall girl, and the dog are dubbed "Four."

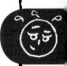

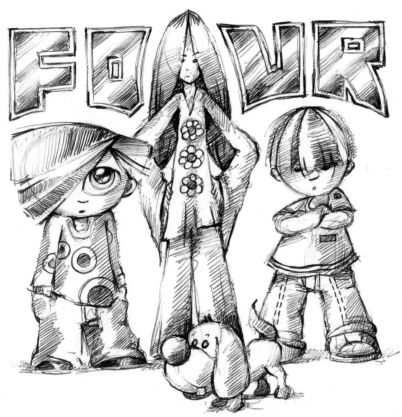

Free and loose shading
style variation: For
this, force yourself
to draw quicker and
be less precise as
you add the shading.
That's how the stroke
becomes looser.

Graphic and reduced style
variation: The shading is
added very consciously,
precisely, and slowly to
give the whole comic a
cool, controlled look.

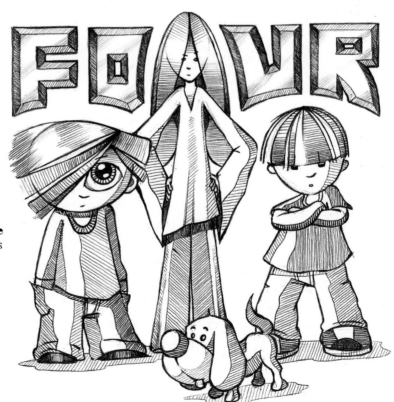

My Life Is a Comic!

These days, people spend a lot of time reflecting on their lives and making it public via social media. The platforms are booming, and selfies are a popular way to capture and share special moments in life. A good old, secretly kept diary seems to have gone out of style. But why not combine various illustration possibilities and create a comic story based on one's life? It could be scanned or photographed and then made public digitally, too.

A pair of circle-comics emerge.

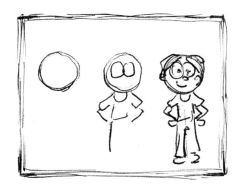 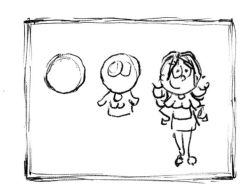

Step 1: Two circles
Step 2: Two circles and few lines for the body
Step 3: The finished circle-stick person

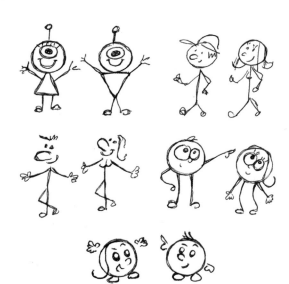

Of course, the figures could look very different from an everyday comic, as these examples show.

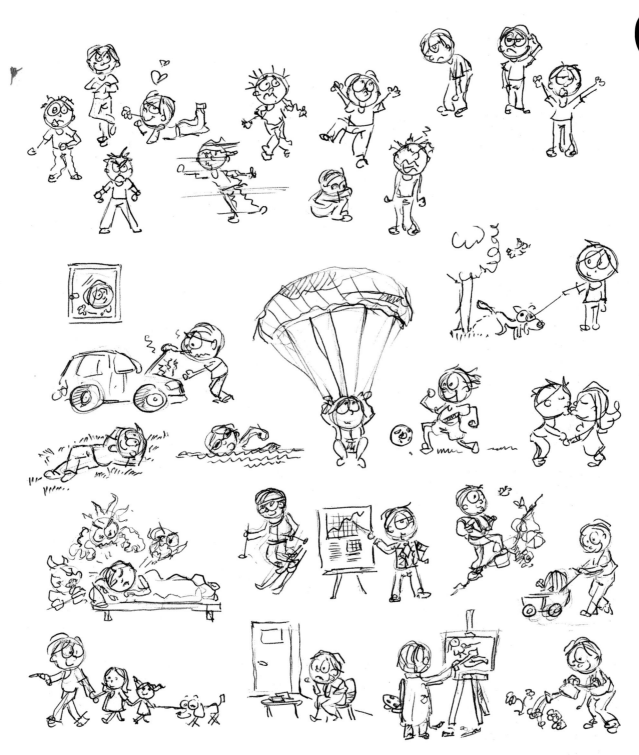

Draw a few practice themes with the figures
and then we can get started.

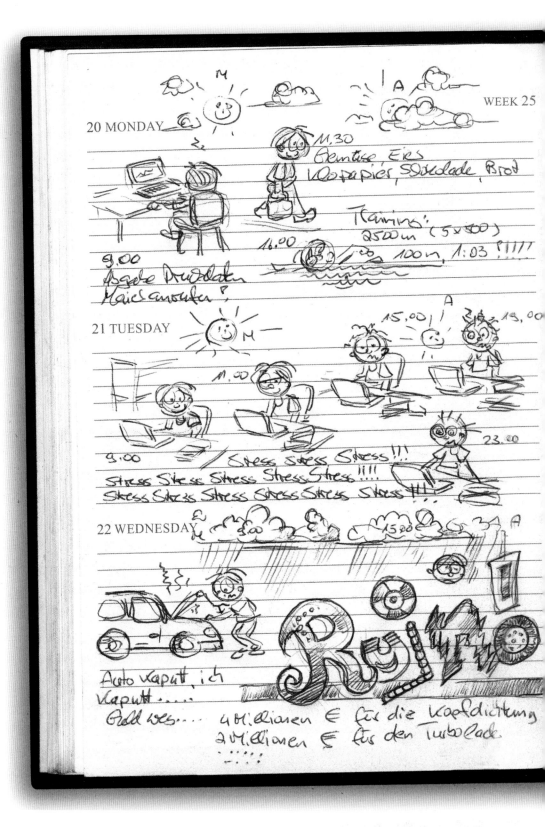

20 MONDAY

11.30
Gemüse, Eier
Klopapier, Schokolade, Brot

Training:
2500m (5×500)
16.00 100m, 1:03 !!!!

9.00
Abgabe Druckdaten
Maies anrufen?

21 TUESDAY

11.00 15.00 19.00

23.00

9.00 Stress Stress Stress!!!
Stress Stress Stress Stress Stress!!!!
Stress Stress Stress Stress Stress Stress!!!

22 WEDNESDAY 8.00 15.00

Auto kaput, ich
kaputt.....
Geld weg..... 4 Millionen € für die Kopfdichtung
 2 Millionen € für den Turbolader
 !

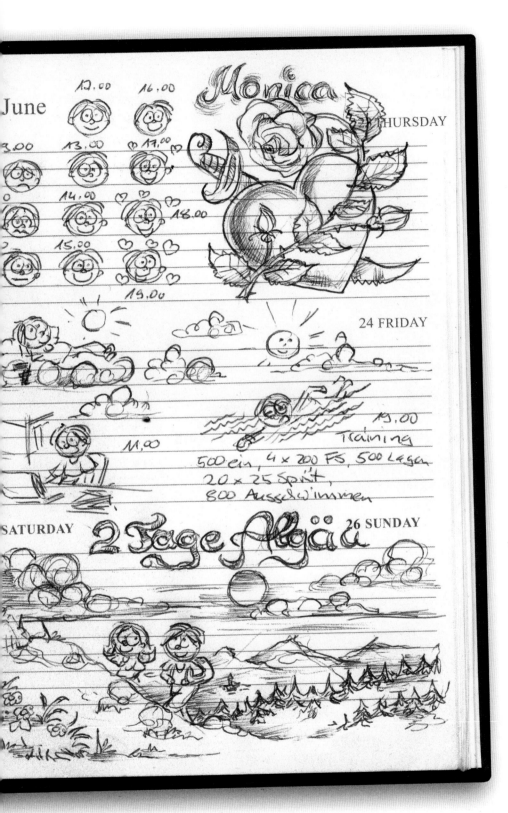

June

12.00 16.00

3.00 13.00 17.00

14.00 18.00

15.00

19.00

Monica

THURSDAY

24 FRIDAY

11.00 19.00
Training
500 ein, 4 × 200 FS, 500 Lagen
20 × 25 Sprint,
800 Ausschwimmen

SATURDAY 2 Tage Allgäu 26 SUNDAY

Who likes to draw stories of everything that life has to offer? Sometimes it's funny to add a mood barometer just like the one on top of the right page. That's how the calendar can be used as a diary as well—anything happening in life can be captured visually.

Surreal Worlds

Surrealism is an art form that pulls inspiration from dreams, the unconsciousness, or absurd and fantasy-like things. The crossover from comic-style to surrealism is fluid, even if the creative influences are different. Nonetheless, in surrealistic painting as well as in comics, things or beings that do not exist in reality are often portrayed. For a long time, comic art has been a good example of this.

Step 1: Sketch of a small strawberry

Step 2: Suddenly it's two and you start to see faces.

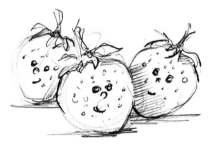

Step 3: That's how they're turned into the Three Strawberry Amigos.

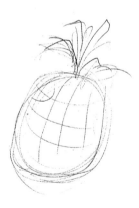

Step 1: Sketch of a normal pineapple

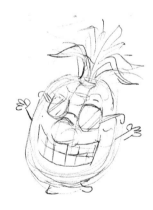

Step 2: Oops, the pineapple suddenly has a face!

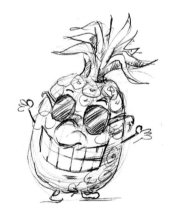

Step 3: The Pineapple Punk is finished.

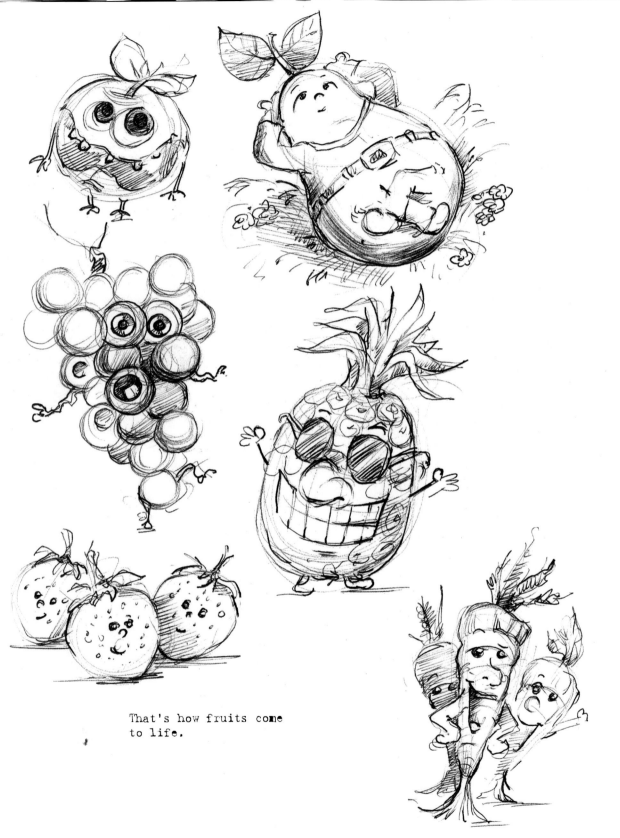

That's how fruits come
to life.

Attack of the Dust Mites

With this idea, comics and surrealism are combined into a funny image.
Simple shapes evolve into peculiar creatures. As if observing them through
a microscope, everything appears really close and it seems as though we're
invading a world of small beasts.

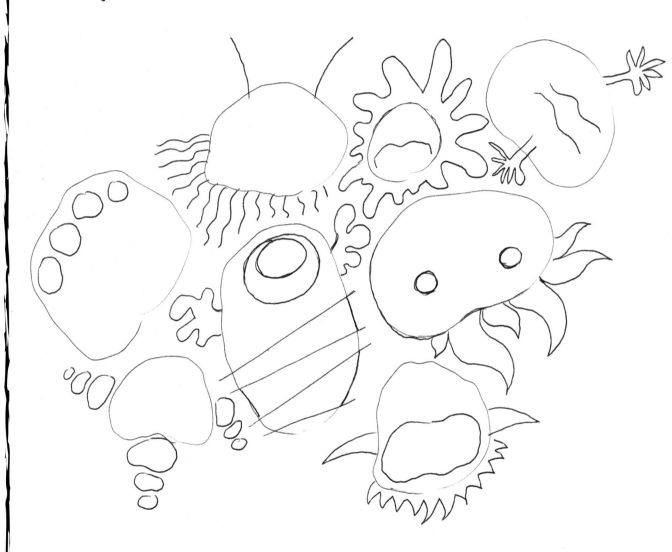

Here are a bunch of simple forms, which seem like
single-cell organisms, amoebae, or bacteria.

A whole world of dust mites! It really doesn't matter what the little beasts look like.

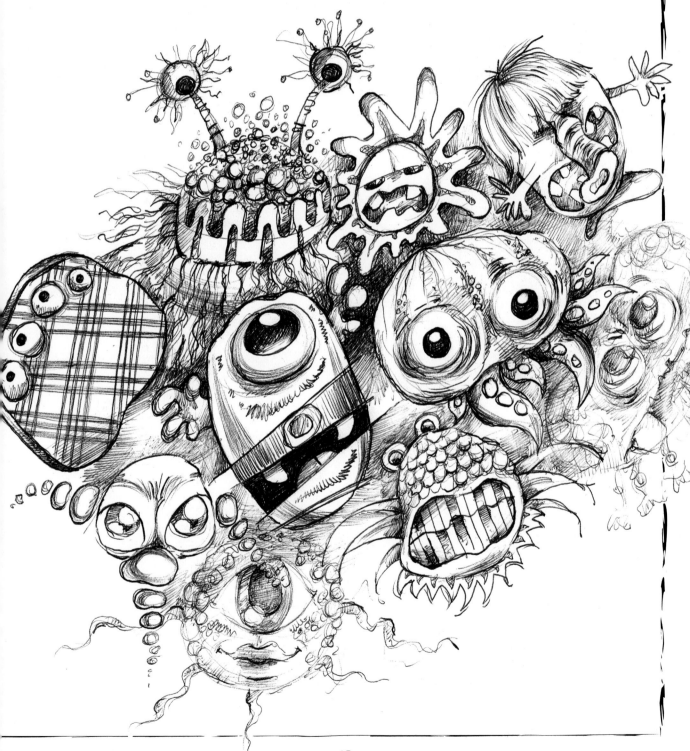

Other Surreal Techniques and Fantasy Worlds

Some people may still remember the technique used on these pages from art class (the technical term is "frottage"), but surrealists have applied it too. Put a piece of paper on top of a rough surface like wood, wicker, or another really rough surface and go over it vigorously with a ballpoint pen. This will create a texture on the paper. Get inspired by the abstract areas and create something new. If holes appear in the paper, try to incorporate them into the art.

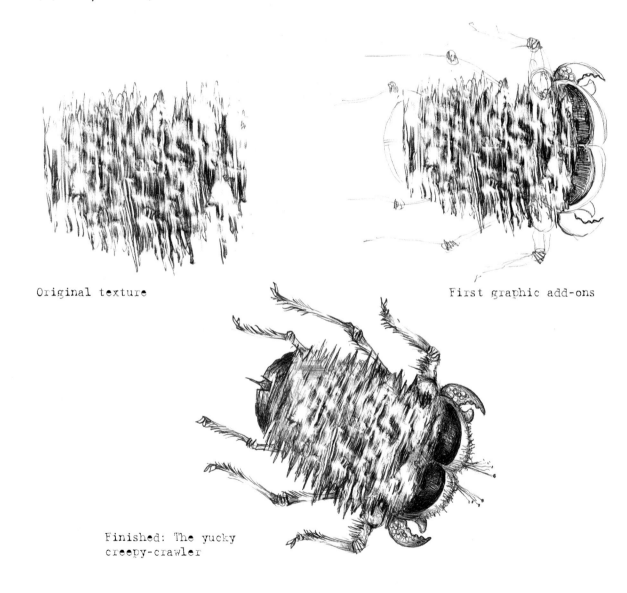

Original texture

First graphic add-ons

Finished: The yucky
creepy-crawler

Original rippled texture

Limbs are added.

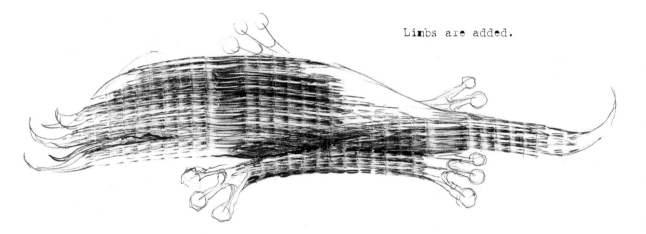

Finished: The odd prehistoric
animal with google eyes

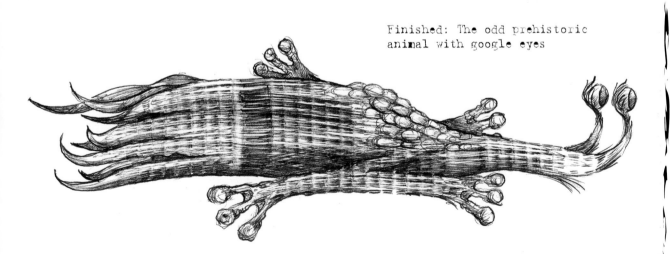

More complex image compositions can be created this way as well
by combining different textures in an organized way.

Various sized areas and
shapes with different
textures

The detail nicely shows the
texture of the surface, in
this case a vegetable grater.

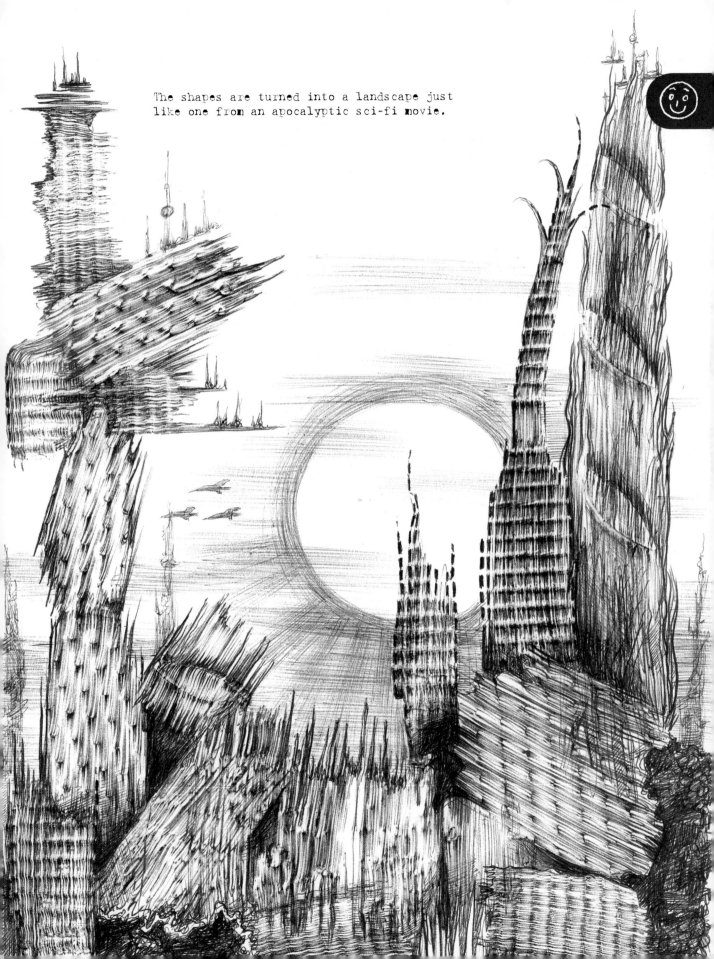

The shapes are turned into a landscape just
like one from an apocalyptic sci-fi movie.

The motif for this theme was coincidental, because it started as nothing more than a test paper. Through mostly unconscious doodling, an odd picture eventually emerged, and it reminded me of cracked wood.

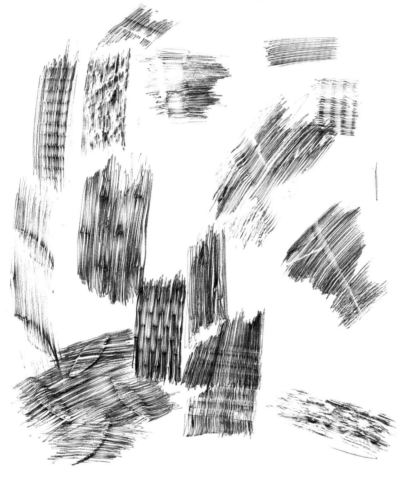

Additions of perspective turn it into a finished picture (right).

It starts out as a test paper for textures.

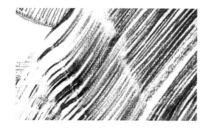

The textures are recognizable in the detail and resemble wood.

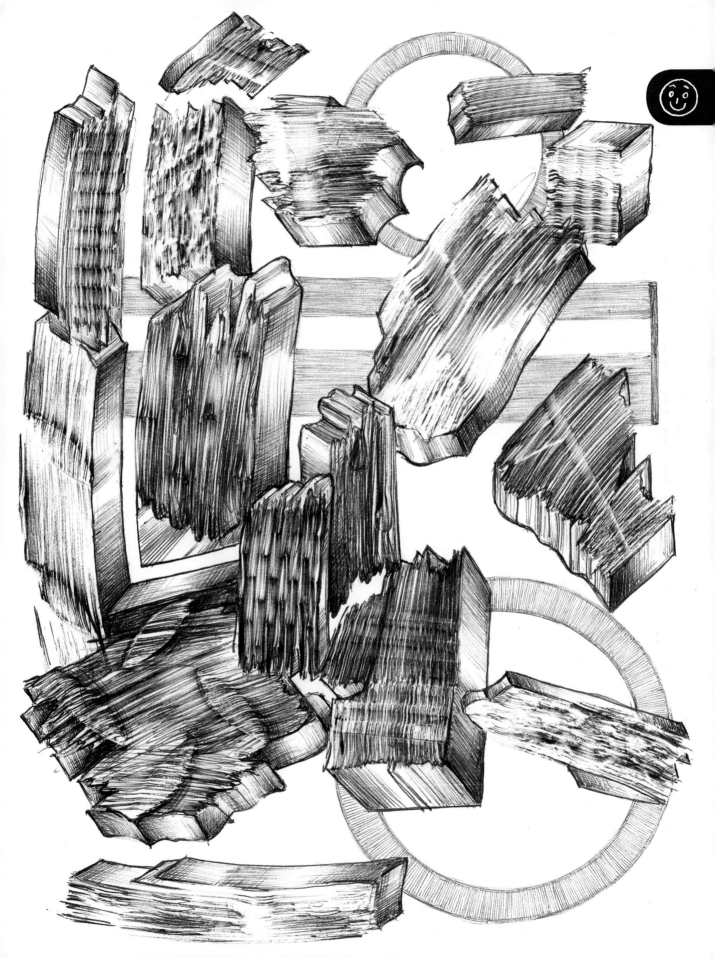

A Small Technical Slide-In

Until now, almost all of this book's themes were drawn in the two-dimensional plane. The last few started to show small perspective and three-dimensional play. Let's take a closer look at three-dimensionality, because more knowledge about useful drawing techniques never hurts.

This shows how two-dimensional representations of a triangle, a circle, and a rectangle are first turned into flat three-dimensional forms. In the bottom row, they're turned into a cone, a ball, and a cylinder with shading techniques.

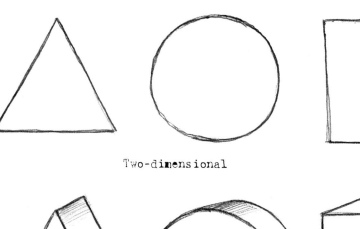

Two-dimensional

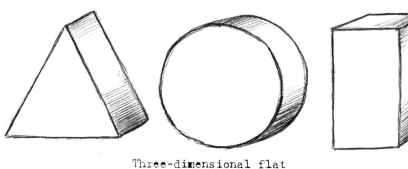

Three-dimensional flat

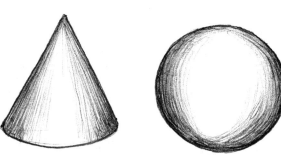

Fully three-dimensional

Light from above

Light skewed from the side

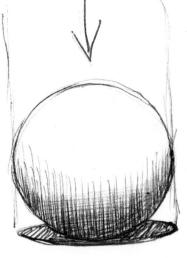

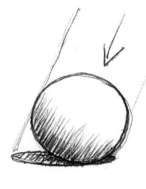

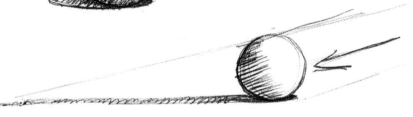

Light from the side. The shadow becomes really long.

Light from behind

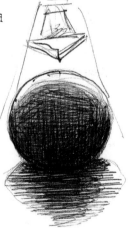

Light and shadow are important for a three-dimensional design, which is why you should always try to envision where the light is coming from and where the darkly drawn shadow falls.

Light skewed from below.

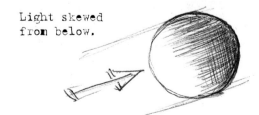

An Abstract Diary

To have an even looser way of working with geometric forms, here is an idea for an abstract drawing that has a hidden meaning. Small areas of text are included, lending the essence of a diary. The experiences of a day (or a week) become a picture, and life an abstract gallery.

The original simple geometric shapes

The German text makes it clear that the finished
abstract image is about a summer's day. Particular
attention should be paid to the text design. In
this image, the font sizes and font widths vary
greatly from line to line.

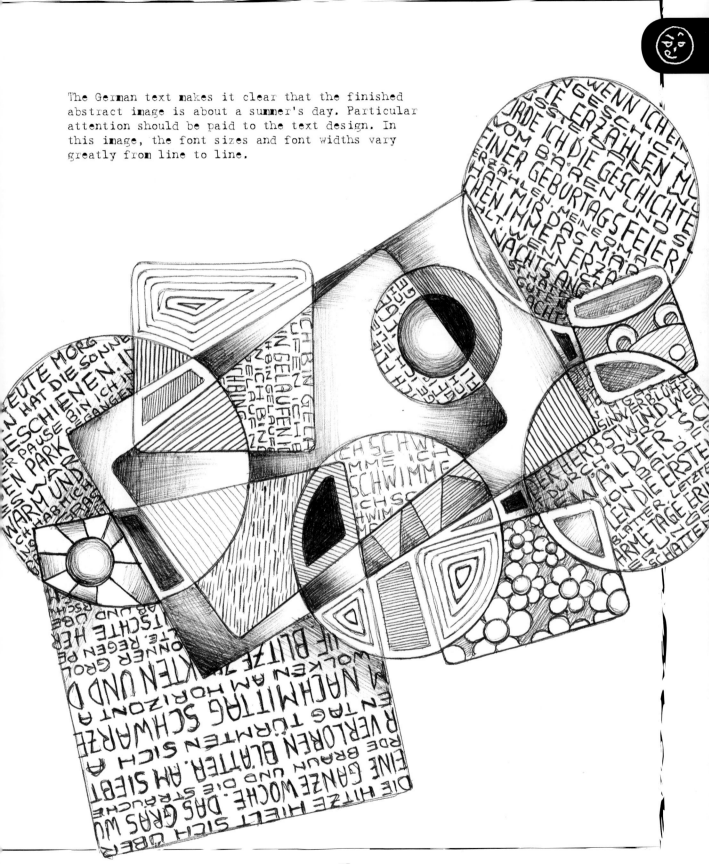

Modern Dream Homes—Construction Vs. Fantasy

There are always two ways to approach an idea: with the mind and with the heart. The mind could give you clear, simple structures, while the heart builds castles in the air. Both are visible on this page.

Who doesn't sometimes dream of a modern, luxury home? With a few lines and basic geometric shapes, futuristic houses are conceptualized.

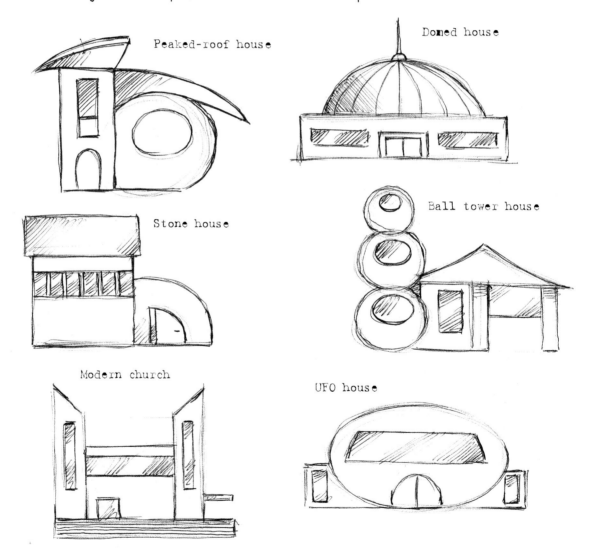

Peaked-roof house

Domed house

Stone house

Ball tower house

Modern church

UFO house

Conceptualized modern architecture in a mini format

Soap bubble house

Horn house

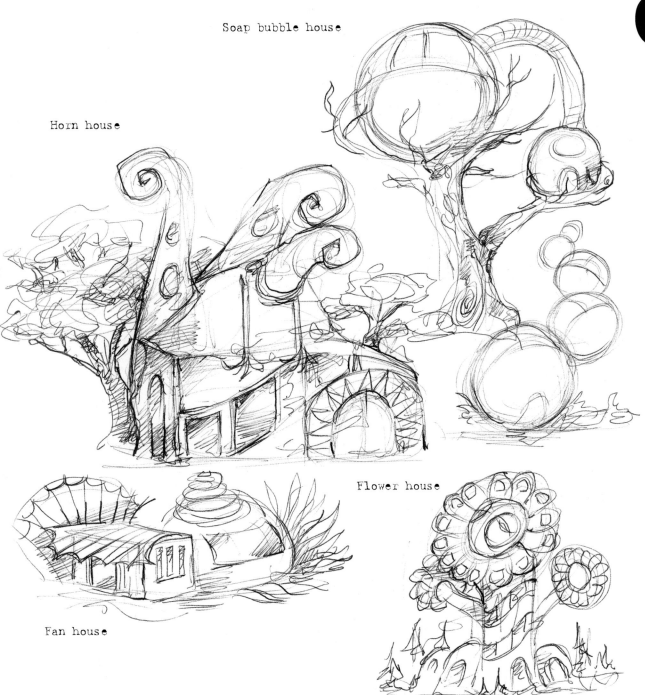

Flower house

Fan house

In contrast, there are no boundaries for these houses—neither for structural engineering calculations nor regarding the materials used. The ideas are solely guided by fantasy without any consideration to ever build it.

Perspective...Or Not?

Most of us learned about perspective in school—but maybe only a few people had fun with it. Well, for some things, understanding comes later on. Because perspective depictions open unknown possibilities, for many the attitude toward it changes—and, suddenly, it is interesting.

Let's start with the four basic forms of perspective:

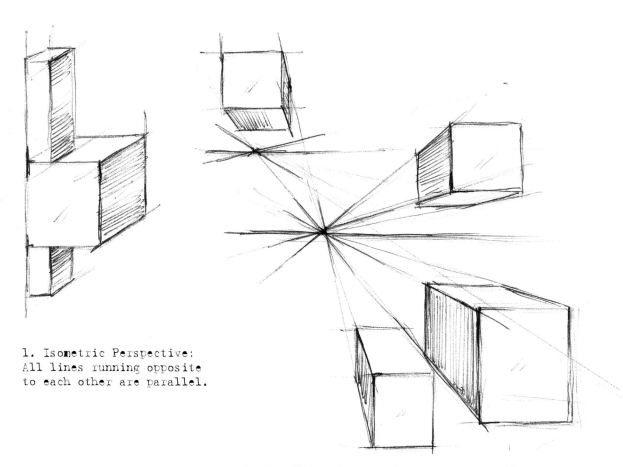

1. Isometric Perspective: All lines running opposite to each other are parallel.

2. One-Point Perspective: In space, all lines running toward the back vanish into one point on the horizon.

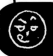

3. Two-Point Perspective:
In space, all lines
running toward the back
vanish into two points on
the horizon.

4. Three-Point
Perspective:
Various lines
vanish into
two points on
the horizon
and the third
vanishing
point clearly
sits below
or above the
horizon.

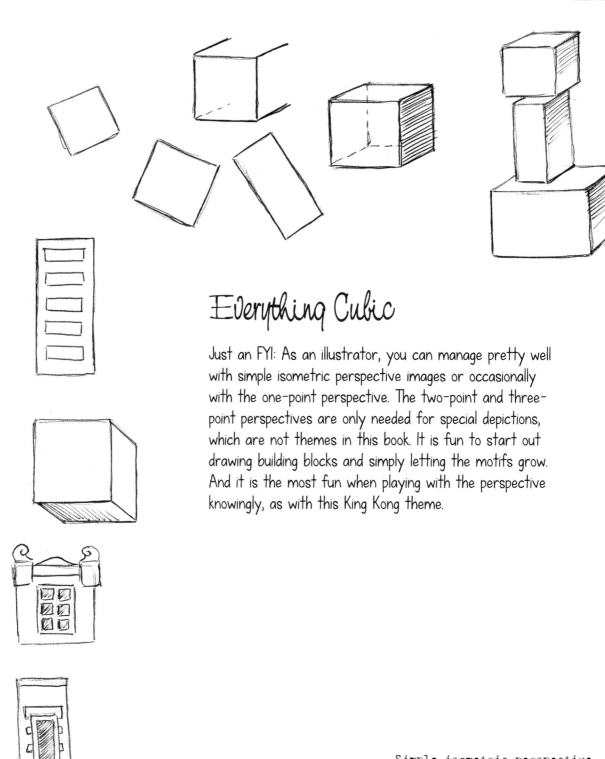

Everything Cubic

Just an FYI: As an illustrator, you can manage pretty well with simple isometric perspective images or occasionally with the one-point perspective. The two-point and three-point perspectives are only needed for special depictions, which are not themes in this book. It is fun to start out drawing building blocks and simply letting the motifs grow. And it is the most fun when playing with the perspective knowingly, as with this King Kong theme.

Simple isometric perspective exercises and King Kong sitting on the top of a bending building (right).

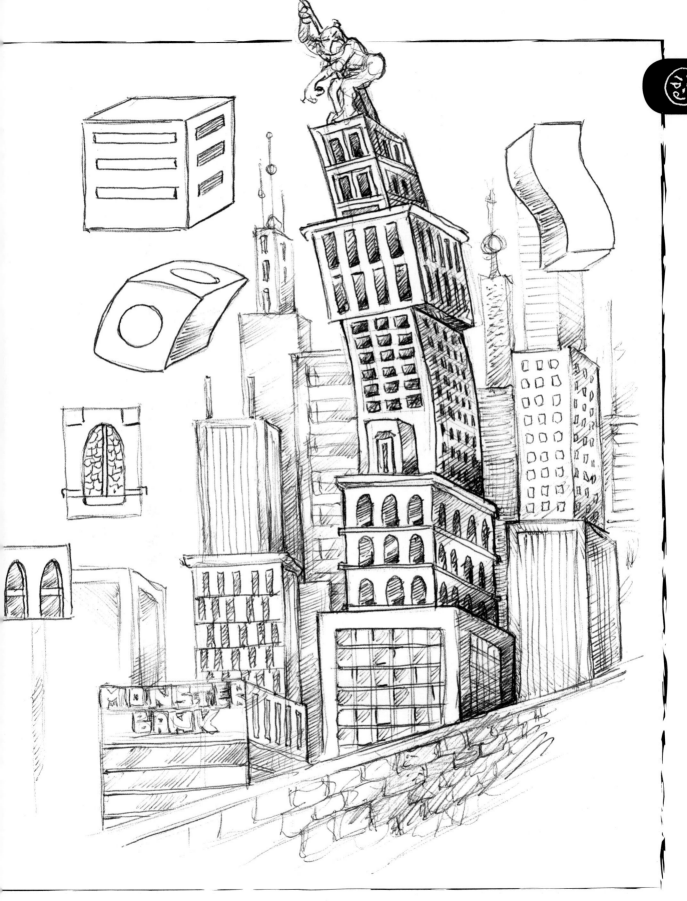

A Ruin Becomes a Fantasy Palace

What do math scrap paper and a factory abandoned for decades have in common? The ballpoint pen brings them together, drafting it into a fantasy palace on the scrap paper.

Sometimes it is good to graphically dream away reality. Even just a little knowledge about perspective is enough. We're ready to go.

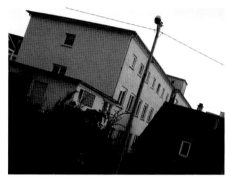
Photo of the old factory

First lines on the scrap paper

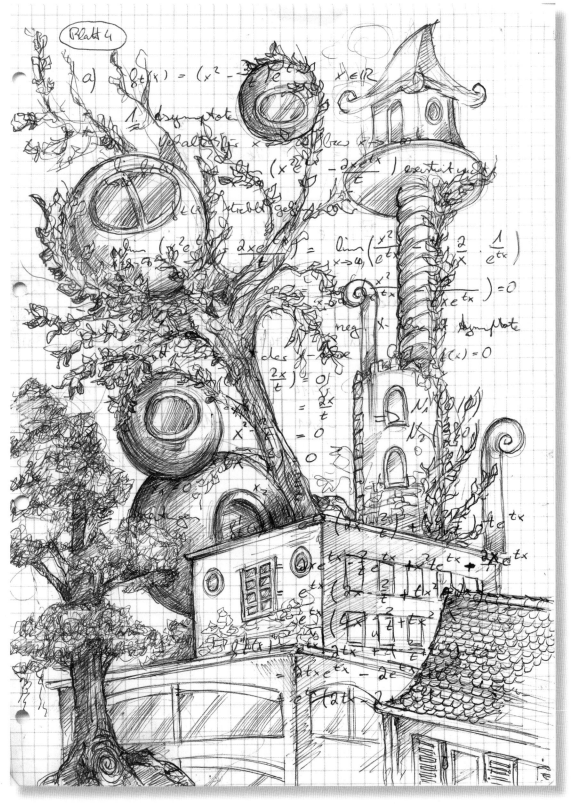

Finished sketch of the fantasy palace

Sketch a Project

Very different possibilities will open up to anybody who has a bit of knowledge about perspective drawing. A few quick, successful lines can be drawn on paper during a presentation. With a little time, it would be easy to give personal ideas shape and form. These sketches show the wish of a little house by the sea— the basic architectural ideas are visible.

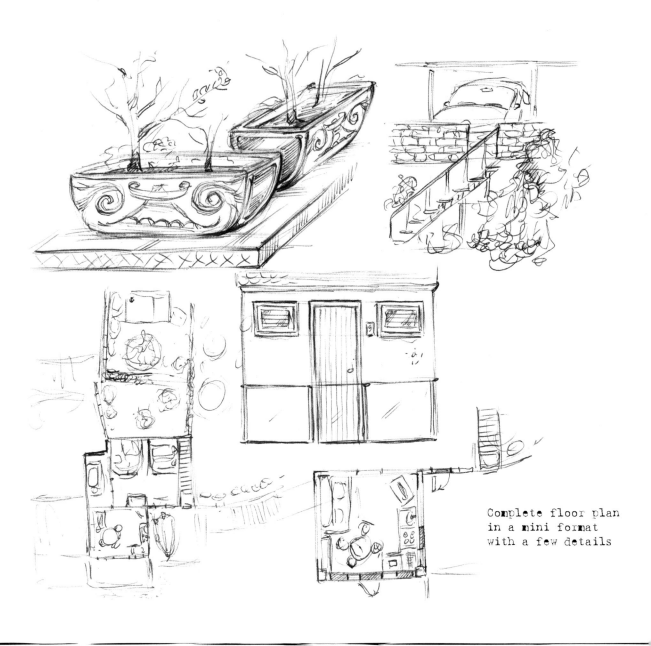

Complete floor plan in a mini format with a few details

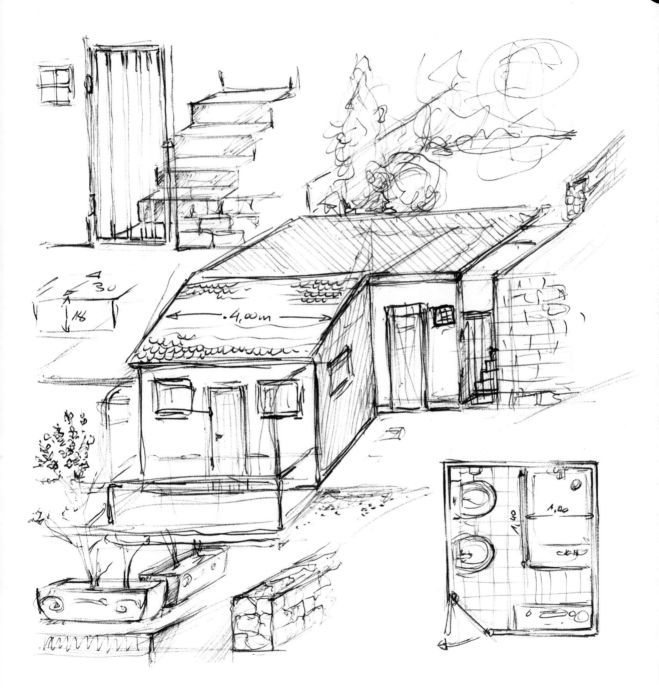

Complete exterior view, details, and the
floor plan for a bathroom

Pixelized Pixels

Who hasn't, during a phone call, unconsciously doodled in the boxes of a piece of graph paper? Scientists have proven that unconscious drawing during a lecture or a talk is not distracting—actually it increases concentration. So, simply leave a scrap paper (or in this case, an old test) on the desk, doodle away, and keep adding to it.

Those with ballpoint pens in different colors can arrange the doodles in color, which makes the unconscious, creative pastime even happier.

Detail of the pixelated printout for the motif on page 89. It is important to check off box by box so you don't lose the overview.

This detail shows how each area is filled in with mini-hatching.

Scrap of paper with box constructions (left)

Pixel Art Meets Hollywood Icons

The term "pixel" means a certain size made up of tiny digital image points. Nowadays, every photo is composed of them. Back in the days of the big Hollywood stars, the digital world didn't exist, so it's even more exciting to combine the two in an artistic way.

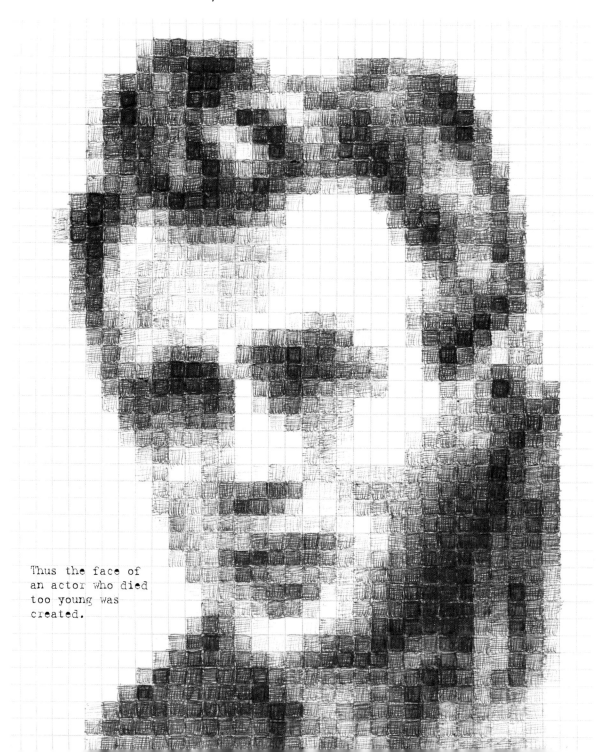

Thus the face of an actor who died too young was created.

First a picture has to be reduced with a computer so it becomes really small and pixelated (i.e. image size of ½" x ½" [1.2 x 1.2 cm] and 72 dpi). Then scale the image to fit a letter size paper and print it so that each pixel roughly matches the size of the boxes on your graph paper. Now you can reproduce it, box by box, in the right brightness on the graph paper.

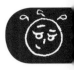

From afar, this female Hollywood legend is recognizable.

Crazy Collages

In the previous section, photos were the source of inspiration, and this time around, photos are directly included in the art. There are two possibilities to do so: cut a photo and glue it directly onto the paper or combine them using a graphic program and print it out. In the second variation, the surface of the paper is better for drawing on than the glossy surface of a photo.

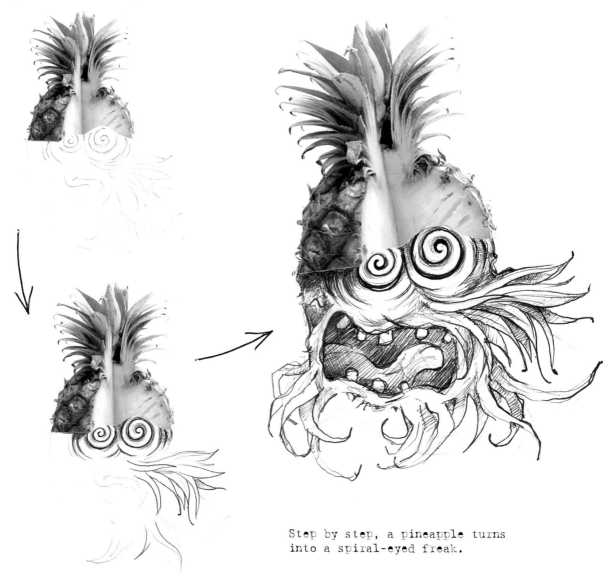

Step by step, a pineapple turns into a spiral-eyed freak.

That's how an apple
troll is created.

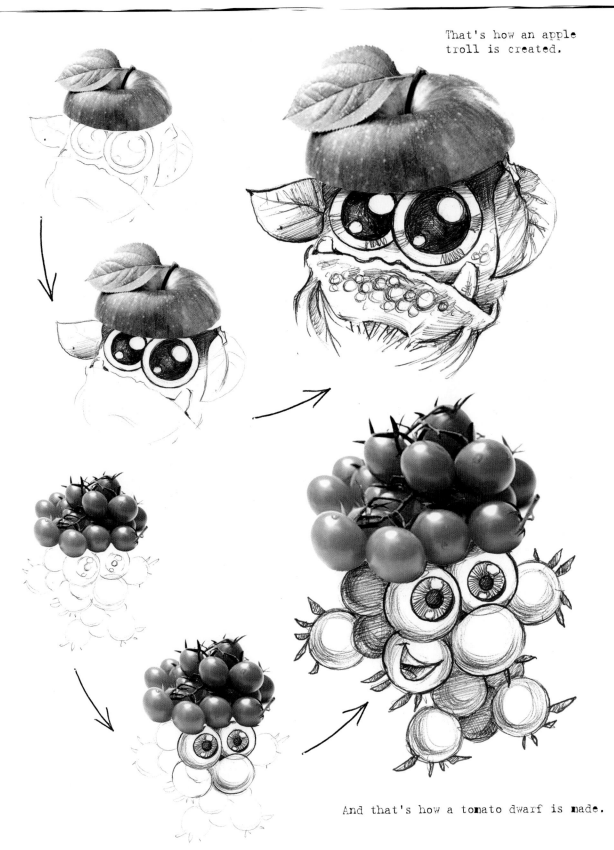

And that's how a tomato dwarf is made.

Scribbly

It is nearly every ambitious illustrator's wish to create imagery with loosely jotted lines and shading. The result that seems so effortless is really the outcome of a demanding process. However, there is a little trick to master it. First, use a laptop or tablet to enlarge a photo to the desired drawing size. Then put a piece of paper on top of the screen and start loosely tracing the contour lines that filter through. (Be careful not to scratch the screen.)

In the process, condense lines in some areas to show darker surfaces, and simultaneously leave blank, lighter ones. Make sure to stop early enough so everything still seems spontaneous and loose.

Small landscapes work very well for practice sketches.

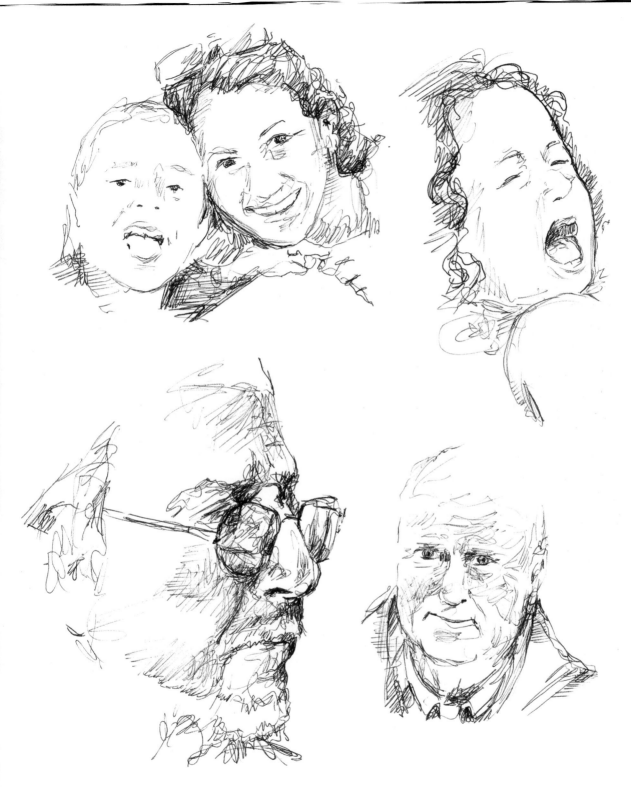

Faces are distinctively harder—especially if you think the
person will recognize him or herself.

With experience, you'll become more confident and can start to take on more complex subjects. Because the scribble technique takes little time, it's not so bad if the sketch doesn't go as planned. Just try it again.

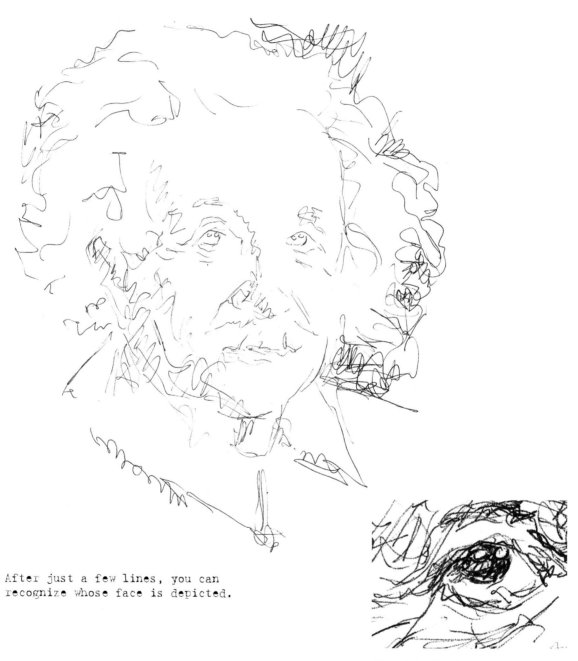

After just a few lines, you can recognize whose face is depicted.

The detail shows one possibility of the scribble technique.

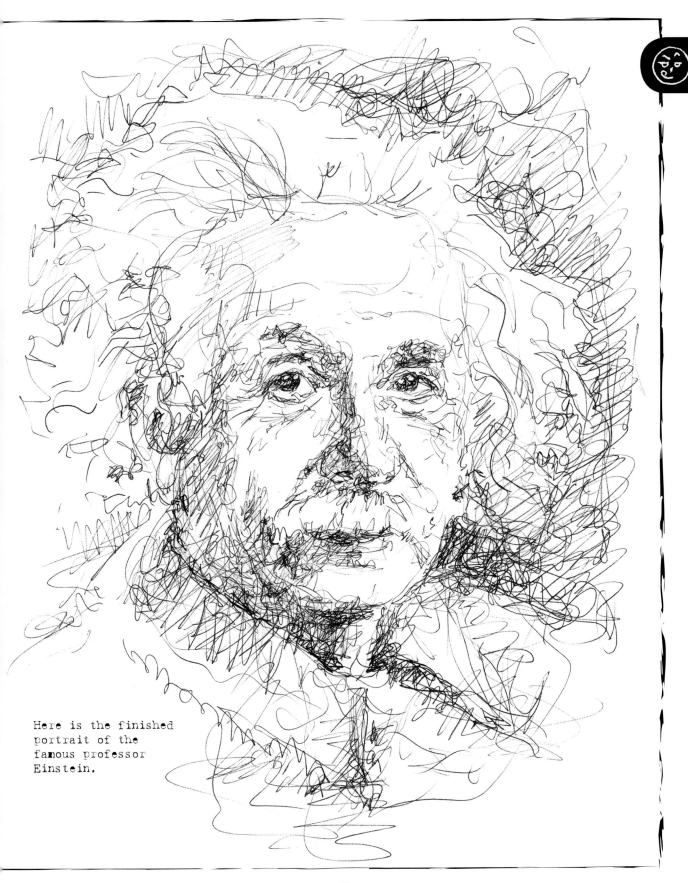

Here is the finished
portrait of the
famous professor
Einstein.

To depict complex images such as the metropolis of New York, it has to be sharply abstracted, meaning it must be simplified. With detail elements such as windows, the picture wouldn't be as recognizable.

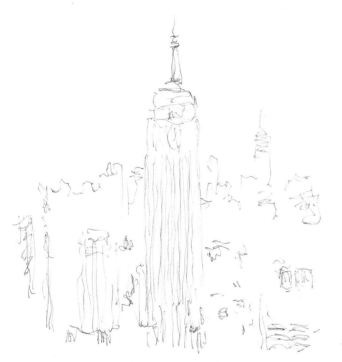

In the enlargement, the abstraction is very obvious.

With just a few lines, the Empire State Building and the surrounding skyscrapers are captured.

Where possible, window and facades elements are added.

In the end, it all turns into
a lively view of the city.

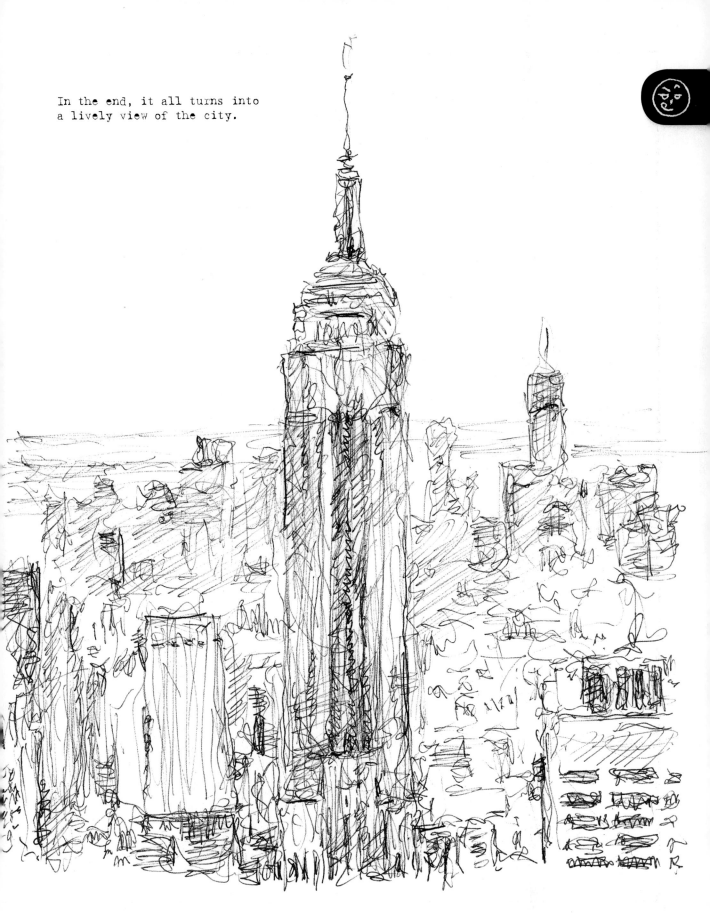

In contrast to the skyscrapers of New York from pages 96-97, here is a drawing of the Ponte Vecchio in Florence, Italy. The interesting thing with this one is the combination of the river, the old facades, and the staggered bridges in the background.

In the enlargement, loosely intertwined lines are visible and almost appear abstract.

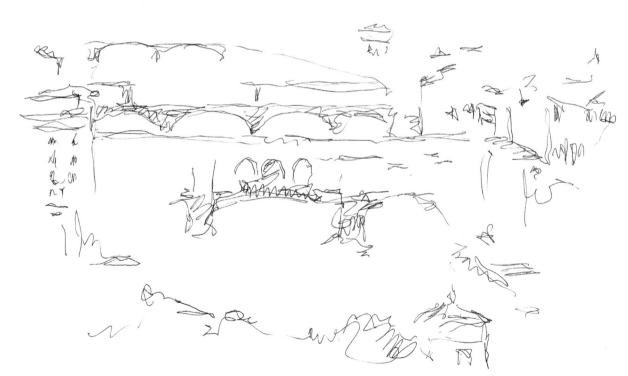

First, loose lines are drawn.

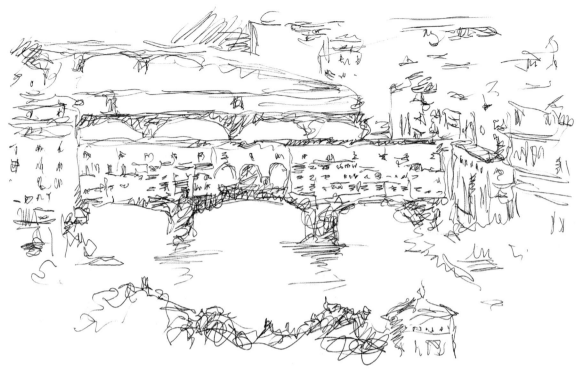

Now draw in facades and windows.

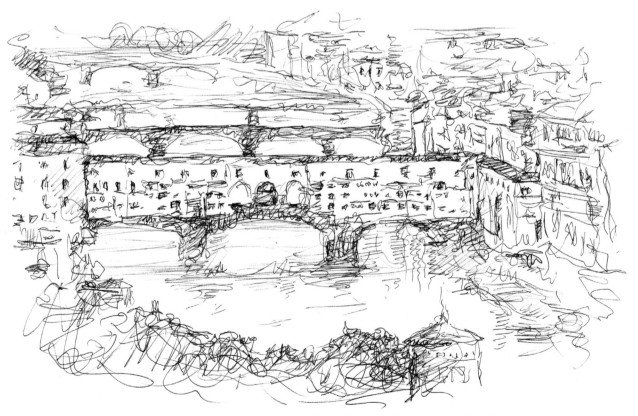

The finished view of the Ponte Vecchio.

Back to Innocence

I have to admit that out of all of the themes in this book, this one gave me the most pleasure. The unselfconsciousness with which children draw, the diversity of shapes and forms, the humor—where does it vanish to as we grow up? Picasso once said it took his whole life to be able to draw and paint like a kid again. Ballpoint pens are just as good for kids as for adults because they're easy to use and smoothly roll over the paper.

The depictions in the first step show the drawings of a five-year old, and then in the second step, what I, with my daughter's consent, turned them into.

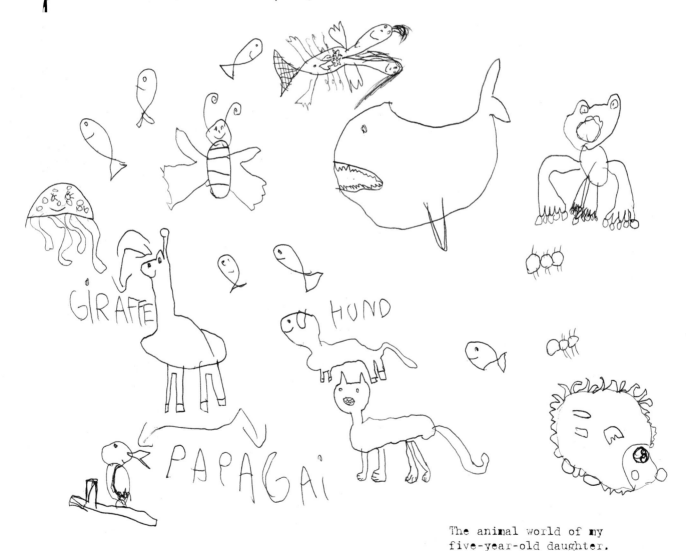

The animal world of my
five-year-old daughter.

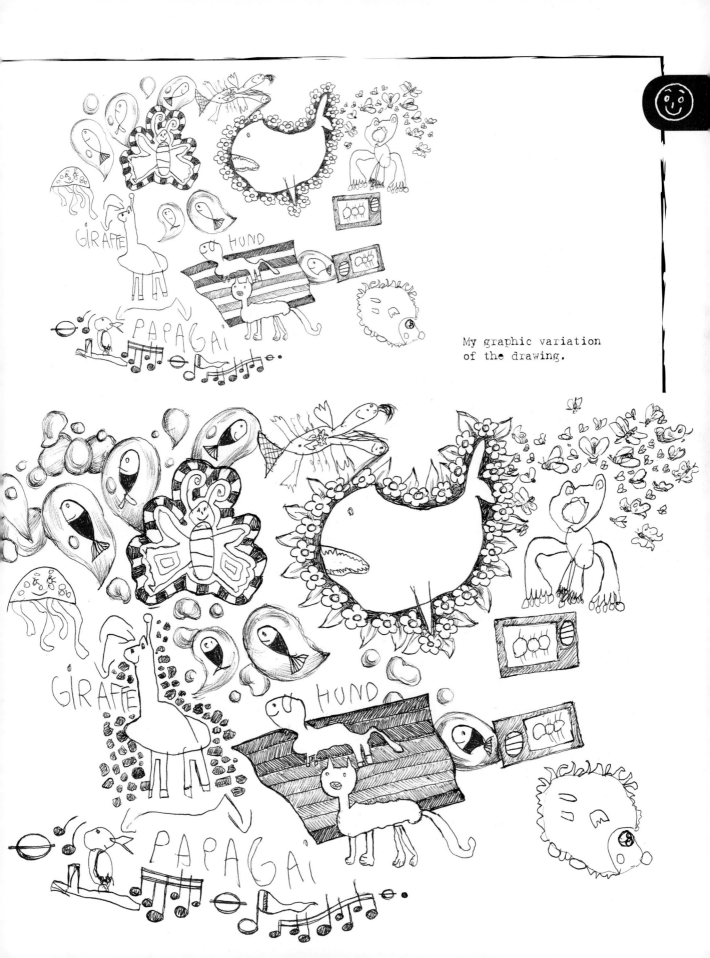

GiRAFFE HUND PAPAGAi

My graphic variation
of the drawing.

GiRAFFE HUND PAPAGAi

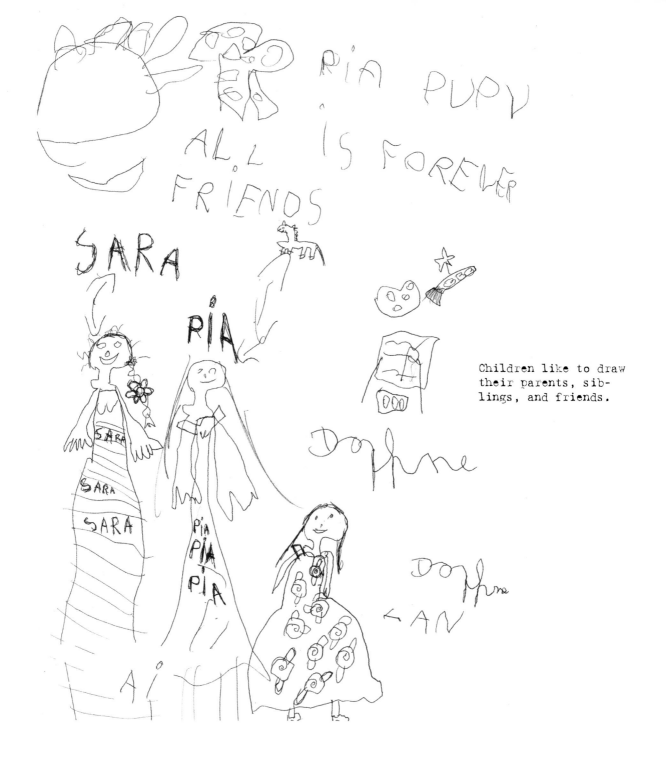

RIA PUPV
ALL IS FOREVER
FRIENDS
SARA
RIA
SARA
SARA
SARA
PIA
PIA
PIA
Ai

Daphne

Daphne
LAN

Children like to draw
their parents, sib-
lings, and friends.

Dad meets daughter,
red-blue detail

The ornaments and hatchings I
added frame the ingenuity of a
childlike viewpoint (right).

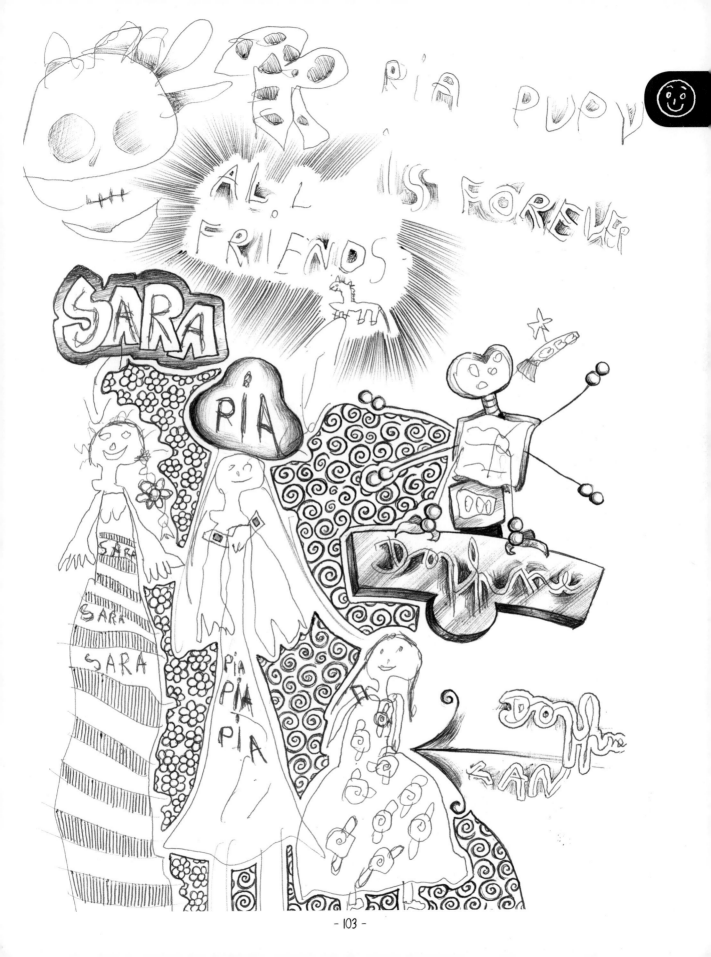

Scraps of Paper

They lay on the desk or on top of the dresser for quick notes. Or they're used while trying to figure out a task. Sometimes a few lines, structures, and shapes are drawn unconsciously too. That's exactly what happened with this original scrap of paper, where suddenly, maybe inspired by a vacation to the south, a few ovals on the paper reminded me of cactus ears. It would be a pity to throw it in the garbage, so let's keep drawing and see what it turns into.

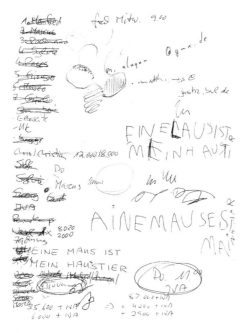

The scrap paper as it lays on the desk

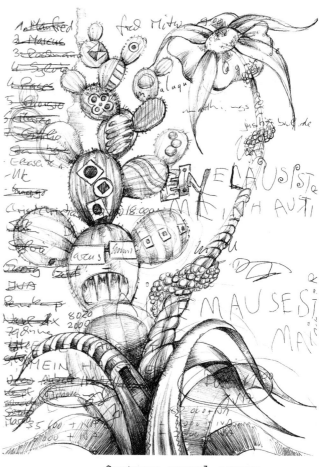

Cactuses sprawl across the paper.

The detail shows the sharp contrast between blue and red ballpoint ink.

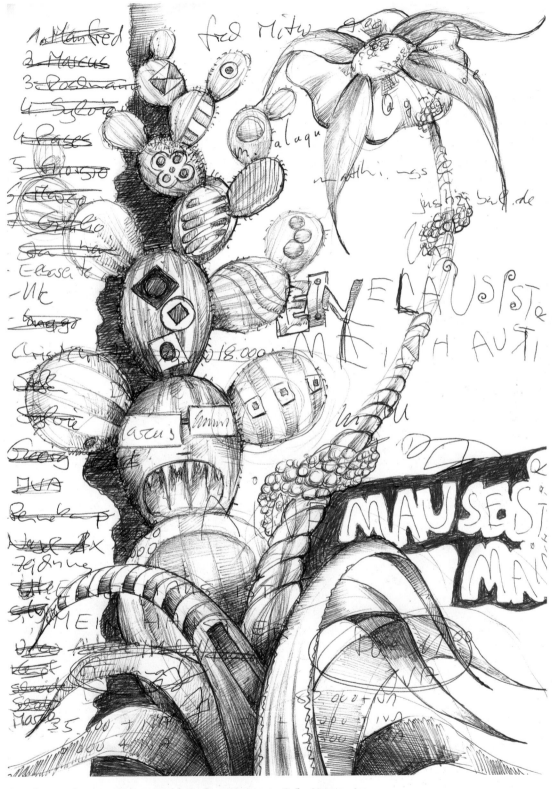

In the end, an unconventional and powerful image is
created—one which could never be planned consciously.

Always and Everywhere

The Endless Possibilities of a Ballpoint Pen

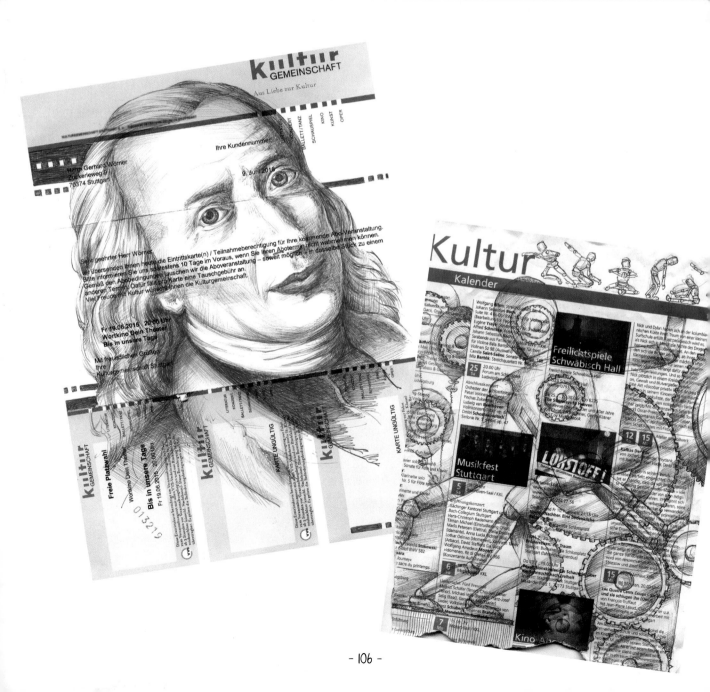

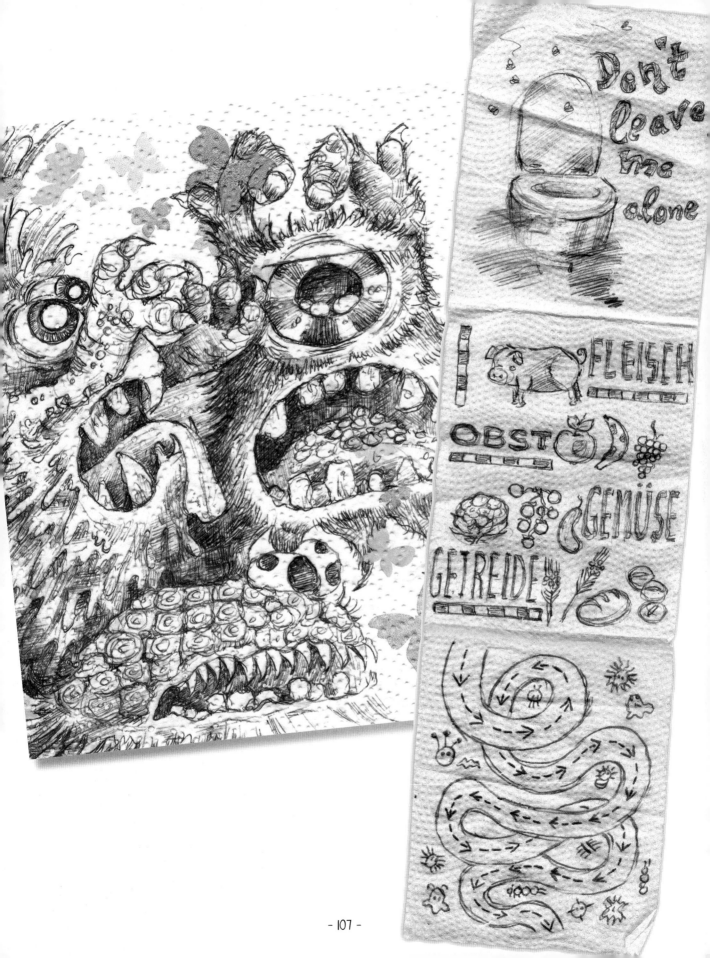

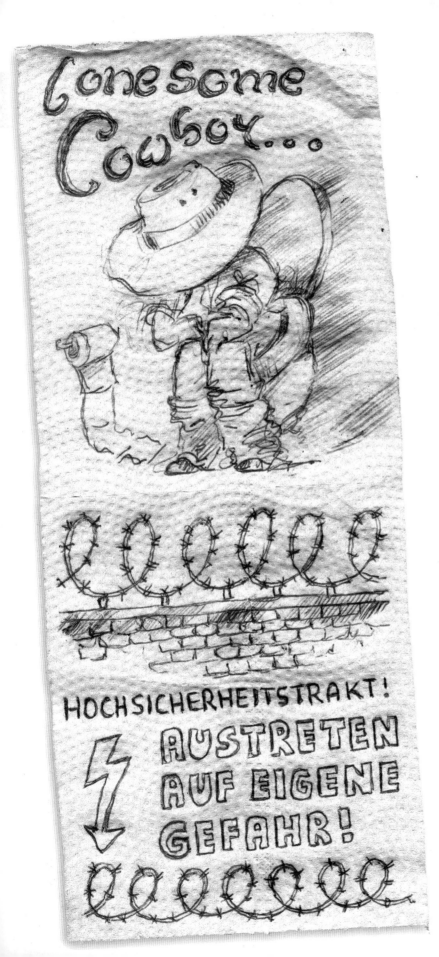

Message for a Successor to the Throne

Sometimes a session on the john takes a bit longer than planned. So why not leave a little message behind for the successor to the "throne"? Some people keep a pen handy in their pocket, maybe along with a small notebook on which the toilet paper can be laid. Let's start a drawing of "can" messages.

Toilet paper messages

High-Security Wing!
Use at Your Own Risk.

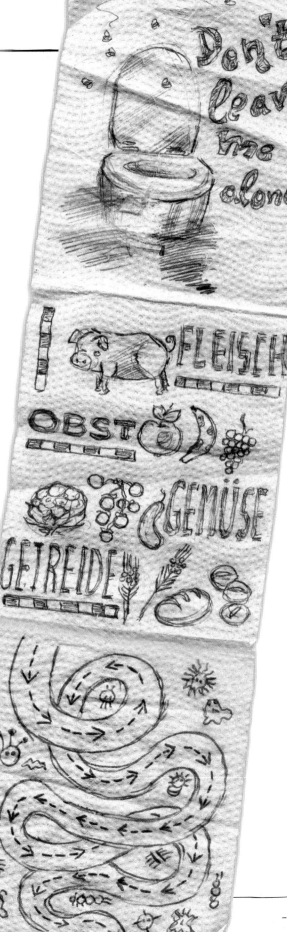

Is it a public toilet or a private one? Do you know who will stop in after to use the place or will it be a stranger? This is what makes the act so exciting—you don't know who will receive the toilet paper message, plus the finder won't know who drew or wrote it. Tact is needed or, on the contrary, you could create an anonymous message, which carries a punch.

Draw carefully because the paper is really soft and rips easily.

Lasting Memories

A hard contrast to the toilet paper messages is this graphic variation. The German poet Matthias Claudius, who made his mark in history with the poem and song "The Moon Has Risen" (also called "Evening Song"), was featured in a theater piece.

A portrait of the poet was created on the program and ticket, which made a beautiful connection between past and present. The drawing technique, photorealism, will be described in detail on page 122.

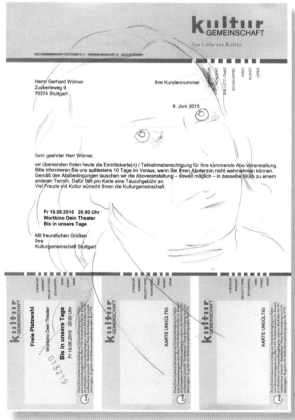

The outlines and first hatchings show the contours of the face.

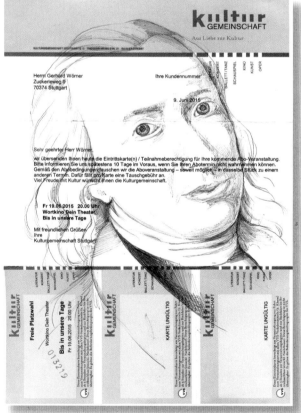

Now details such as the eyes and mouth can be developed more.

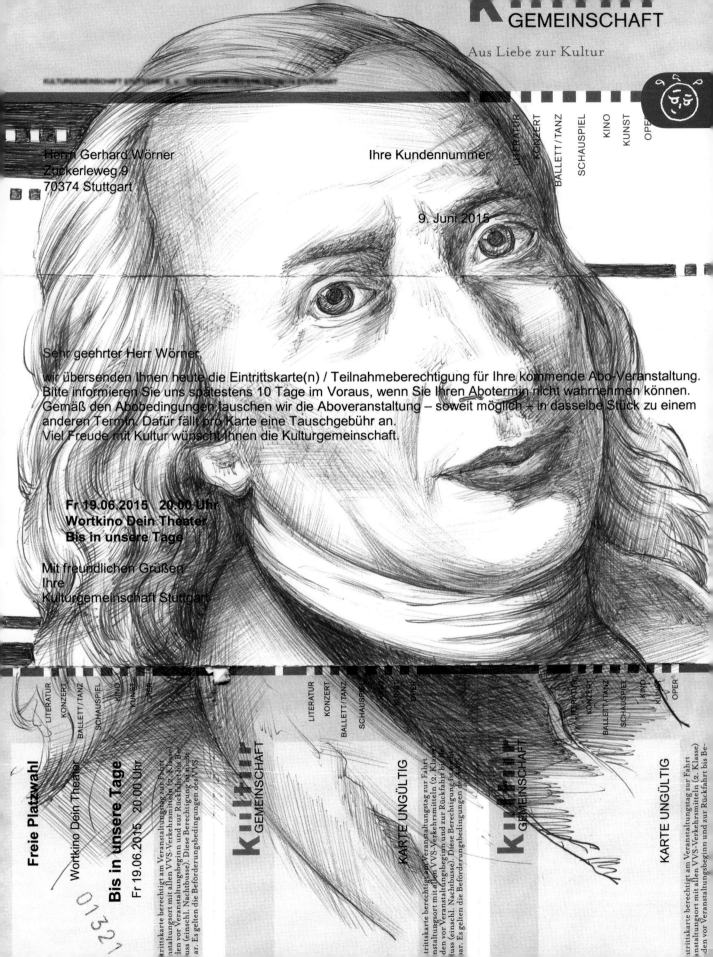

GEMEINSCHAFT

Aus Liebe zur Kultur

Herrn Gerhard Wörner
Zuckerleweg 9
70374 Stuttgart

Ihre Kundennummer

9. Juni 2015

LITERATUR KONZERT BALLETT / TANZ SCHAUSPIEL KINO KUNST OPER

Sehr geehrter Herr Wörner,

wir übersenden Ihnen heute die Eintrittskarte(n) / Teilnahmeberechtigung für Ihre kommende Abo-Veranstaltung.
Bitte informieren Sie uns spätestens 10 Tage im Voraus, wenn Sie Ihren Abotermin nicht wahrnehmen können.
Gemäß den Abobedingungen tauschen wir die Aboveranstaltung – soweit möglich – in dasselbe Stück zu einem
anderen Termin. Dafür fällt pro Karte eine Tauschgebühr an.
Viel Freude mit Kultur wünscht Ihnen die Kulturgemeinschaft.

Fr 19.06.2015 20.00 Uhr
Wortkino Dein Theater
Bis in unsere Tage

Mit freundlichen Grüßen
Ihre
Kulturgemeinschaft Stuttgart

Freie Platzwahl

Wortkino Dein Theater

Bis in unsere Tage

Fr 19.06.2015 20.00 Uhr

01321

LITERATUR KONZERT BALLETT / TANZ SCHAUSPIEL KINO KUNST OPER

LITERATUR KONZERT BALLETT / TANZ SCHAUSPIEL KUNST OPER

Kultur
GEMEINSCHAFT

KARTE UNGÜLTIG

LITERATUR KONZERT BALLETT / TANZ SCHAUSPIEL KINO KUNST OPER

Kultur
GEMEINSCHAFT

KARTE UNGÜLTIG



Stabat mater
mater
talwerke von Vincenco
Garsi, Orazio Bassani u. a.

Uhr
dwigsburg

Violine, Gesang & Kom
Mair (Violine & Gesang)
nn (Violine, Gesang &
ne-Theres Stocker (Pia
ika & Gesang), Marlene
ntrabass & Gesang)

Uhr
dwigsburg

g-Strong
Viola & Gesang)
olincello & Gesang)

hr Einführung
hr Ordenssaal
oss Ludwigsburg

re Parisienne
Patrick Höfich (Klarinette),
avier)
-midi d'un faune

vier solo (Auswahl)
Sonate für Flöte und Klavier

larinette solo
Nr. 5 für Flöte solo

rinette und Klavier
in:
Paris« für Klavier solo

Uhr
rt Schlosspark
sburg

ntemps
hloss'spiele
eitung)
ach, Leopold Stokowski
e c-Moll BWV 582

aara
Journey«
e sacre du printemps

wigsburg

Express Orchestra
eninstrumente & mehr)
010 Fa



Wolfgang **Rihm**: Streichquartett Nr. 4
Johann Sebastian **Bach**:
Suite Nr. 4 Es-Dur BWV 1010 für Violoncello
(Bearbeitung für Fagott)
Eugène **Ysaye**: Sonate op. 27 Nr. 3 »Ballade«
Alfred **Schnittke**: Fuge für Violine
Johann Sebastian **Bach**:
Sarabande aus Partita Nr. 2 d-Moll BWV 1004
für Violine Béla Bartók: 44 Duos für zwei
Violinen Sz 98 (Auswahl)
Camille **Saint-Saëns**: Sonate G-Dur op. 168
Béla **Bartók**: Streichquartett Nr. 6 Sz 85

25 Sa 20.00 Uhr
Forum am Schlosspark
Ludwigsburg

Abschlusskonzert
Orchester der Schlossfestspiele
Pietari Inkinen (Leitung)
Pinchas Zukerman (Violine)
Ludwig van **Beethoven**:
Violinkonzert D-Dur op. 61
Dmitri **Schostakowitsch**:
Sinfonie Nr. 5 d-Moll op. 47

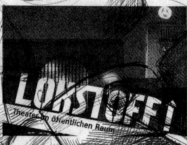

Musikfest Stuttgart

5 Sa 19.00 Uhr
Beethoven-Saal / KKL

Eröffnungskonzert
Gächinger Kantorei Stuttgart und
Bach-Collegium Stuttgart
Hans-Christoph Rademann (Leitung),
Tilman Michael (Einstudierung Chor),
Marlis Petersen (Elettra), Stella Doufexis
(Idamante), Anna Lucia Richter (Illia),
Lothar Odinius (Idomeneo), Kenneth Tarver
(Arbace), David Steffens (La Voce)
Wolfgang Amadeus **Mozart**:
»Idomeneo, Rè di Creta« KV 366
(Konzertante Aufführung)

6 So 19.00 Uhr
Mozart-Saal / KKL

Liedertafel: Fünf Freunde
Markus Schäfer (Tenor), Christian Elsner
(Tenor), Michael Volle (Bariton), Franz-Josef
Selig (Bass), Gerold Huber (Klavier)
Lieder, Volkslieder und Vokalquartette von
Franz **Schubert**, Johannes **Brahms** und
Felix **Mendelssohn-Bartholdy**

7 19.00 Uhr



Freilichtspiele Schwäbisch Hall

Freilichtspiele Schwäbisch Hall
Am Markt 7
74523 Schwäbisch Hall
Telefon 0791 751-600

Sa 25.7., 20.30 Uhr, Abo 8225
The Stairways to Heaven
Eine Revue über die 70er und 80er Jahre
von Christoph Biermeier, Georg Kistner
und Coy Middlebrook

LOKSTOFF!
Theater im öffentlichen Raum

Kartenverkauf über
www.kulturgemeinschaft.de,
www.lokstoff.com oder
Telefon 0711/224 77-56

Do 9.7. und Fr 10.7. jeweils 21.15 Uhr
**Vorher/Nachher. Eine bedenkliche
Reise im Bus**
Spielort: Bushaltestelle Schlossplatz
Stuttgart (fahrender Linienbus)

Sa 11.7., 20.15 Uhr
Brüderreisen: ein Traum
Spielort: Bushaltestelle Schlossplatz
Stuttgart (fahrender Linienbus)

Do 23.7., 19.00 Uhr
**Revolutionskinder. Ein Schauspiel über
die Sehnsucht nach Freiheit**
Spielort: Stadtbibliothek Stuttgart
Mailänder Platz 1, 70173 Stuttgart



Nick und Dylan haben sich an der kolumbia-
nischen Küste ihren Traum von einer kleinen
Surfschule erfüllt. Fast paradiesisch wird es,
als Nick sich in Maria, die Nichte des Drogen-
barons Pablo Escobar, verliebt. An den wen-
den sich die Brüder um Hilfe, als ihnen lokale
Kleinganoven aufsetzen. Der mächtige »Patr-
on« regelt die Dinge für seinen neugewon-
nenen »Sohn«, verlangt dafür aber schon
bald Gegenleistungen. Und so findet sich
Nick plötzlich in einem Kreislauf aus Korrupti-
on, Gewalt und Blutvergießen wieder.
Eine Art »Escobar privat« liefert Andrea Di
Stefano in seinem Kinoerstling vor traum-
hafter Palmenkulisse, der eher den Famili-
enmenschen als den notorischen Verbre-
cher zeigt. Mit differenziertem Spiel er-
weckt Oscar-Preisträger Benicio del Toro
den monomanen Gangster zum Leben, ge-
schickt mischt der Filmemacher nach eig-
nem Skript Fakten mit Fiktion.

12 So **15 Mi** Atelier am Bollwerk
114 Minuten

Kafkas Der Bau
von Jochen Alexander Freydank, D 2015
mit Axel Prahl, Josef Hader, Devid Striesow

Franz hat sich in seinem Berufs- und Famili-
enleben perfekt eingerichtet. Doch fürch-
tet er ständig, dass die von ihm aufgebau-
te Ordnung gestört werden könnte – von
anderen Menschen oder von allen mögli-
chen ominösen Gefahren. Er beginnt sich
zurückzuziehen, zu verbarrikadieren, seine
Wohnung in einen Bunker zu verwandeln.
Der mit dem Kurzfilm-Oscar prämierte Re-
gisseur Jochen Alexander Freydank legt ein
beklemmendes Drama nach Franz Kafkas
unvollendetem Text vor. Das psycholo-
gische Drama mit komischen Außenseiten
entwickelt sich von Dystopia bisweilen
zum Horrorfilm. Der vor allem als Münste-
raner »Tatort«-Kommissar bekannte Axel
Prahl zeigt in der Hauptrolle eindrücklich
die ganze Bandbreite seines Könnens und
wird von renommierten Kollegen wie Devid
Striesow und Josef Hader ergänzt.

15 Mi Delphi Arthaus Kino
96 Minuten, 20.00 Uhr

**Les Quatre Cents Coups – Sie küssten
und sie schlugen ihn (OmU)**
von François Truffaut
mit Jean-Pierre Léaud, Claire Maurier u. a.
Truffaut Filmreihe in Zusammenarbeit mit
dem Institut français de Stuttgart

Am liebsten schwänzt Antoine Doinel die
ihm verhasste Schule und schaut sich Filme
im Kino an. Dafür kassiert er von seiner
herzlosen Mutter und seinem Stiefvater reg

The Culture Machinery

Let's stick with the art and culture scene a bit longer. This page is pulled from a culture calendar with announcements for various events. Drawn on it are mannequins or figures that recall Oskar Schlemmer's figure drawings. A machinery fantasy is outfitted with gears and a person moving within it and another bound to it. In a few lines, the figures and gears are sketched on the drawing paper, and after, hatchings are added.

The detail shows the interesting combination of printed letters and hand drawn ballpoint pen lines.

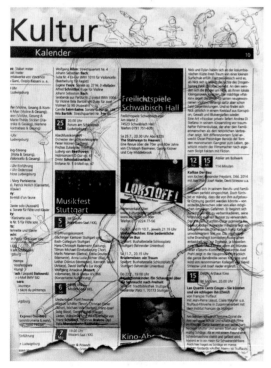

The basic layout of the culture calendar serves the composition of the figures.

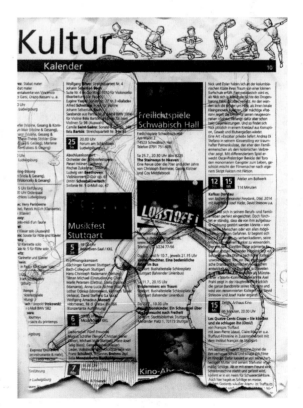

Monsters Hunt Butterflies

A roll of paper towels with butterflies printed on it is just asking to have a funny, mean drawing added to it. And so the world of butterfly-eating monsters is born. Technically, it is not that simple. Just like with the toilet paper, you have to pay attention so the soft, multi-layer paper doesn't rip while you draw on it.

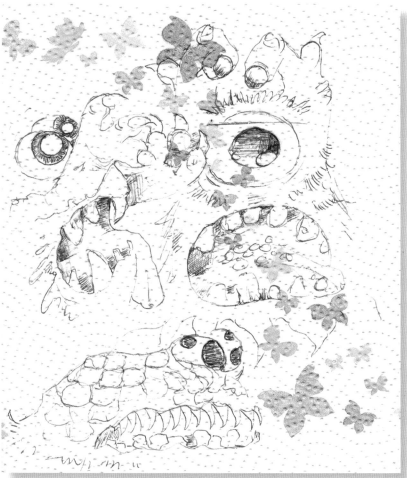

The snatching monsters are outlined.

The detail shows a part of the monster's mouth.

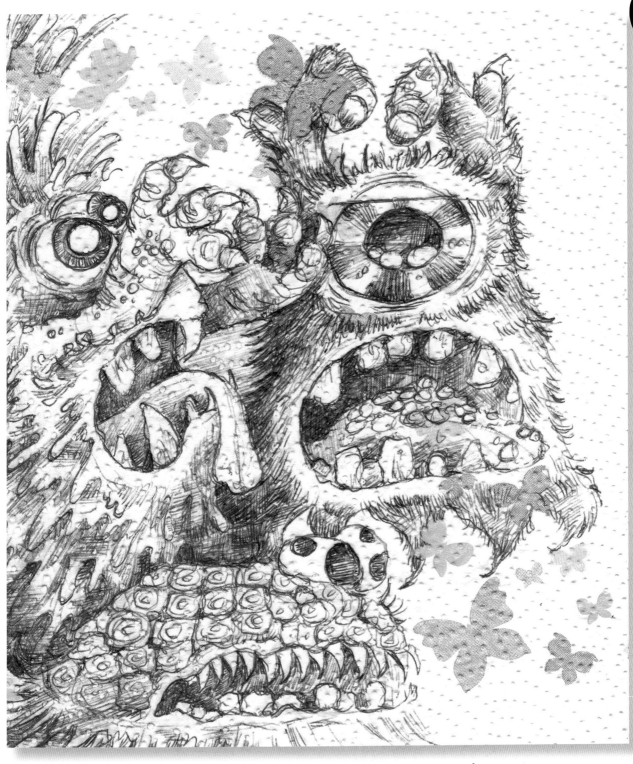

With shading and textures, the monsters come
alive and catch colorful butterflies.

When the Mailman Rings...

...nowadays he mostly brings bills, advertisements, or letters from the IRS. Personal letters have become a rarity in an age of smartphones and tablets. Surprise a loved one by sending something via regular mail—even better with an envelope creatively decorated with original designs.

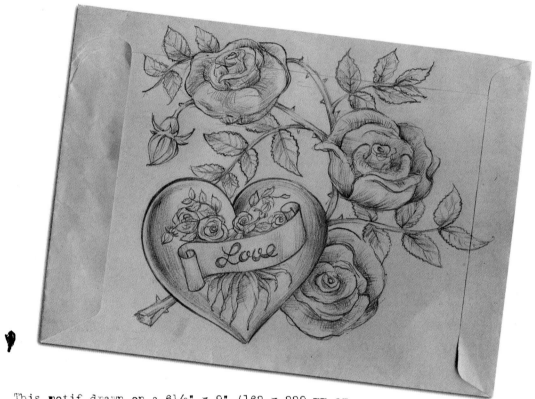

This motif drawn on a 6½" x 9" (162 x 229 mm or DIN A5) envelope is useful for a romantic purpose.

The detail shows the fine hatchings of a rose blossom.

The motif on a 9" x 13" (229 x 324 mm or DIN A4)
envelope shows a happy mail image. The technique
resembles that of the fish on page 20.

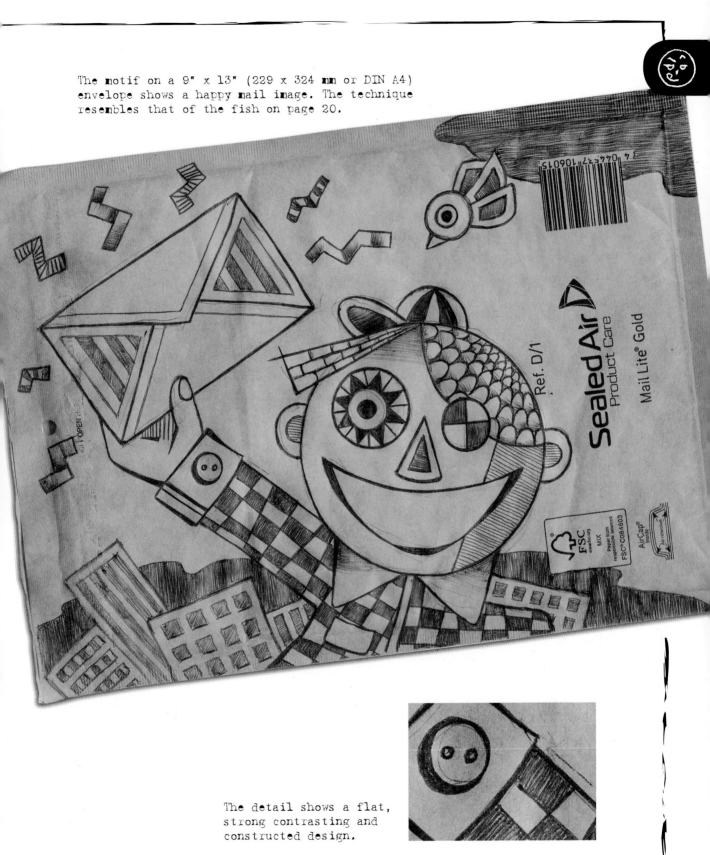

The detail shows a flat,
strong contrasting and
constructed design.

The Book of Secrets

Even with all of the technical innovations, social media, and digital images flooding us, books still hold a special allure. Some people still want to keep a private book to write and view their personal secrets. Such a notebook deserves a special design. So let's take out that ballpoint pen and draw yourself into a hero or mystery girl (or even something very different) on the cover.

The light brown color of the cover lends the drawing a bit of a retro look right from the start.

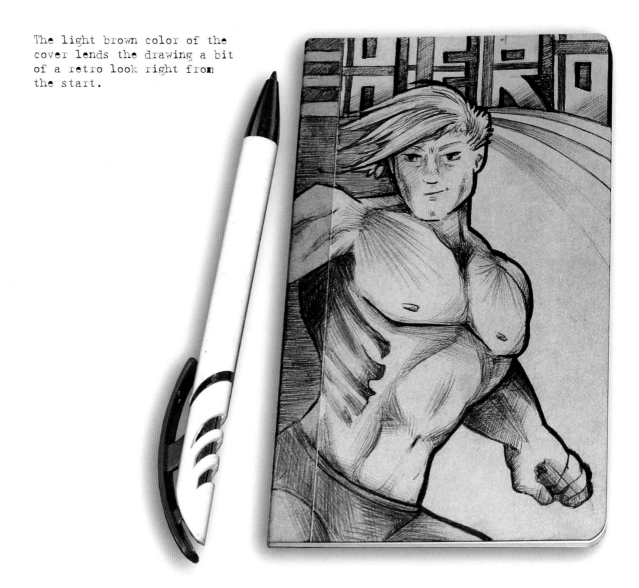

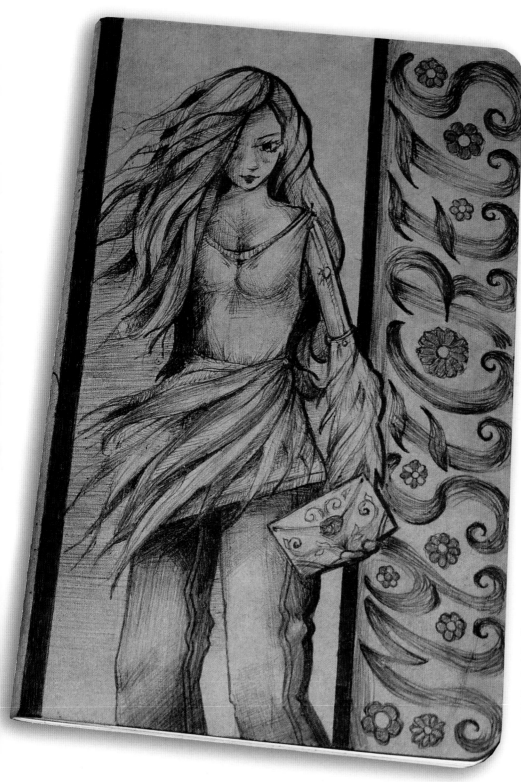

The retro look
occurs as the
blue of the
ballpoint pen
mixes with the
light brown of
the cover.

Observing and Caricature

A while back, I was sitting out at a pool, observing the other visitors. I couldn't help myself and took the notepad from my bag, and with quick ballpoint lines drew the people in an exaggerated style to make it more fun. And then there was that old tote bag hanging in the bushes along the fence, and it looked at me so pitifully. "Okay," I thought, "if you really want to." Soon after, a couple that really inspired me was immortalized on the dirty fabric.

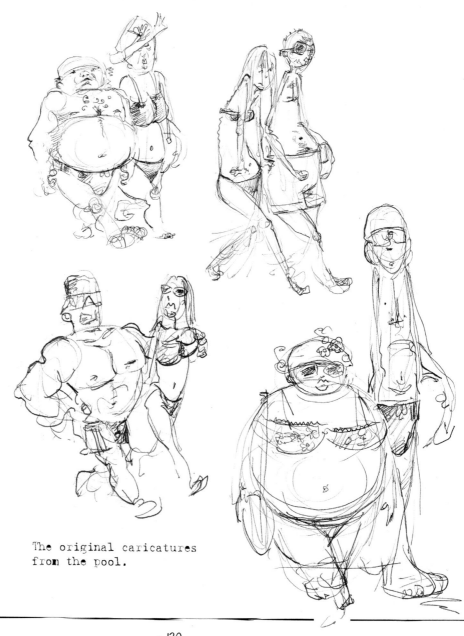

The original caricatures
from the pool.

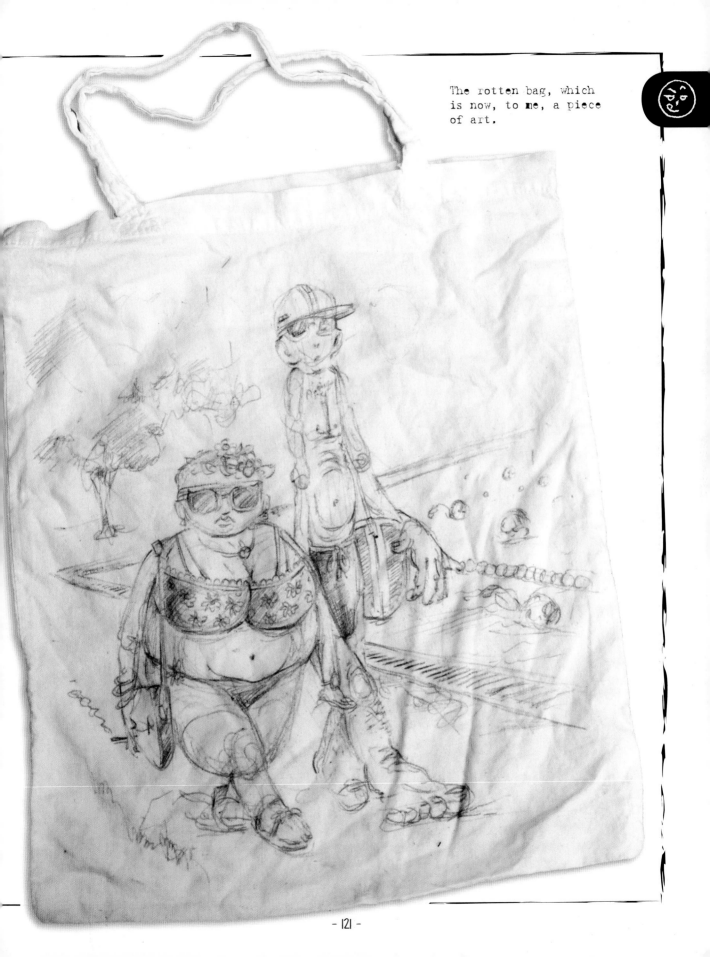

The rotten bag, which
is now, to me, a piece
of art.

Photorealism

Photorealism with a ballpoint pen? Impossible.
That's what many people think. So it is especially
important to start the experiment and to push
the technical boundaries of the material. It is
best to pick three subjects with different levels
of difficulty: a water drop (easy), cherries
(medium), and an eye with eyelashes (hard).
The technical basis for photorealistic drawings
is the hatching and fine shading techniques
from page 15, because the transitions should
be very smooth without hard edges. These fine
hatchings should be mastered already, and a lot
of patience should be brought to the table—then,
the drawing will succeed.

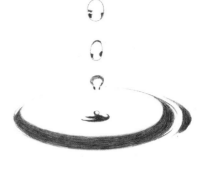

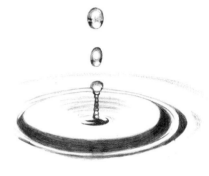

In the first step, clean outlines
are drawn and a few distinct dark
areas are filled in.

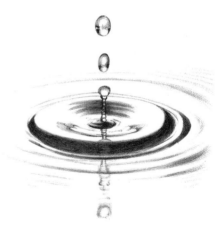

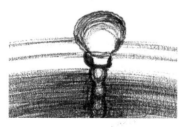
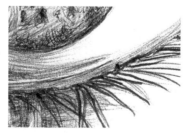
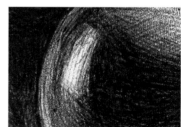

On the enlarged details, it is good to see how smooth
the hatching and color transitions are.

In the second step, lighter
hatchings are drawn and
transitions from light to
dark are created.

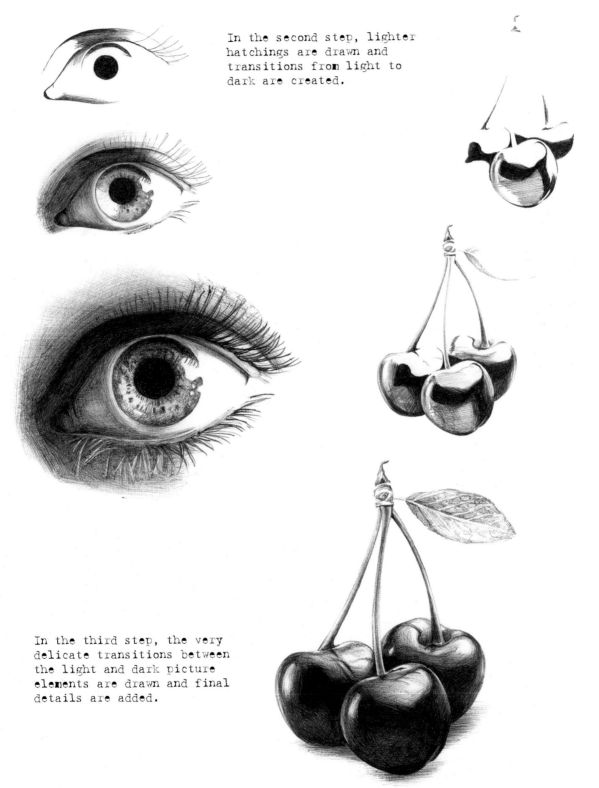

In the third step, the very
delicate transitions between
the light and dark picture
elements are drawn and final
details are added.

Scorpion

A level harder is the scorpion, with many little details and textures on the surface. Because of this, it is really important to draw with a lot of patience and accuracy to get each aspect correct.

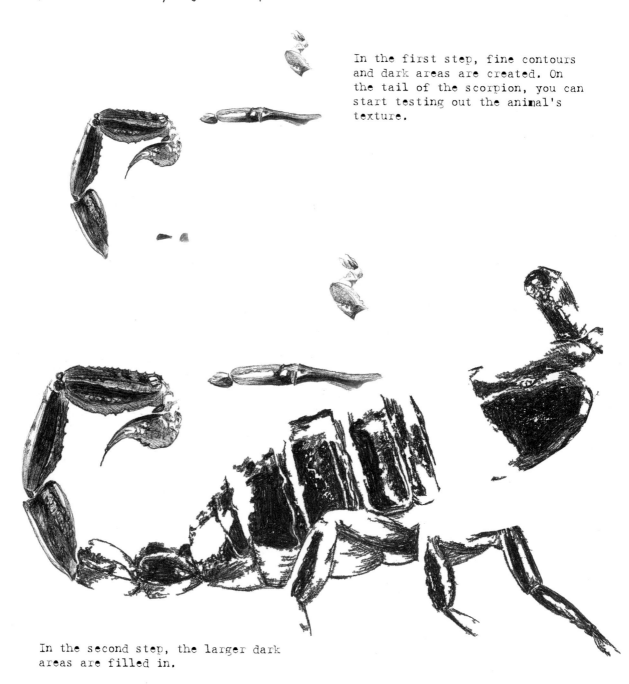

In the first step, fine contours and dark areas are created. On the tail of the scorpion, you can start testing out the animal's texture.

In the second step, the larger dark areas are filled in.

In the enlarged detail, it is
easier to see which techniques
were used to draw the fine-pored,
uneven surface close to and
around the claw.

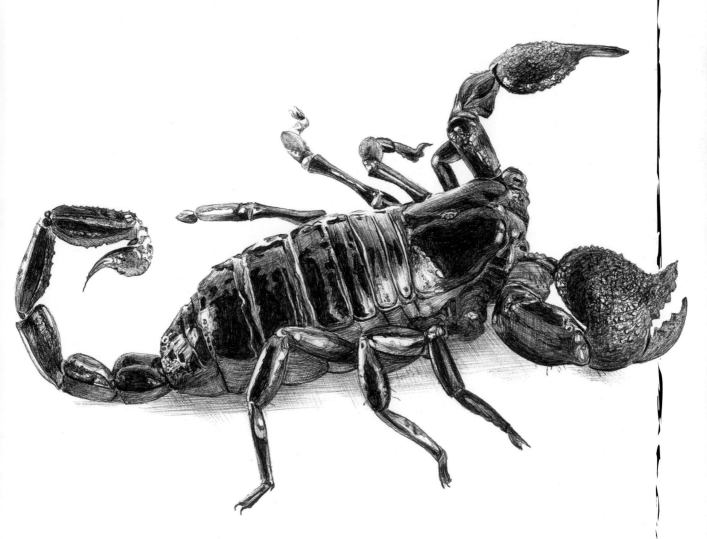

In the third step, the fine transitions are
hatched and the finished animal emerges.

A Walk across the Mudflats

By now, you can create very hard levels of difficulty. I thought for a while and decided on a picture of a walk across the mudflats. People of different ages, small faces, partially in shadow, reflections on the water, wrinkles, and so much more. The motif is ideal to really see what a ballpoint pen can do. If you can't create the base drawing freehand, you can use a little trick. That is, the template drawing is traced really lightly, but the outlines are not traced—instead, the areas are copied in grayscale similar to the subject in "Pixelized Pixels," on page 87. Then, work the same way as you did with the rest of the photorealism section. But even more so here, patience and concentration are necessary, because, unfortunately, ballpoint ink is not erasable.

The picture shows the approach while tracing—both the contours and the outlines of the individually shaded areas are traced.

The face of the woman shows how fine the hatchings have to be so that the face seems realistic.

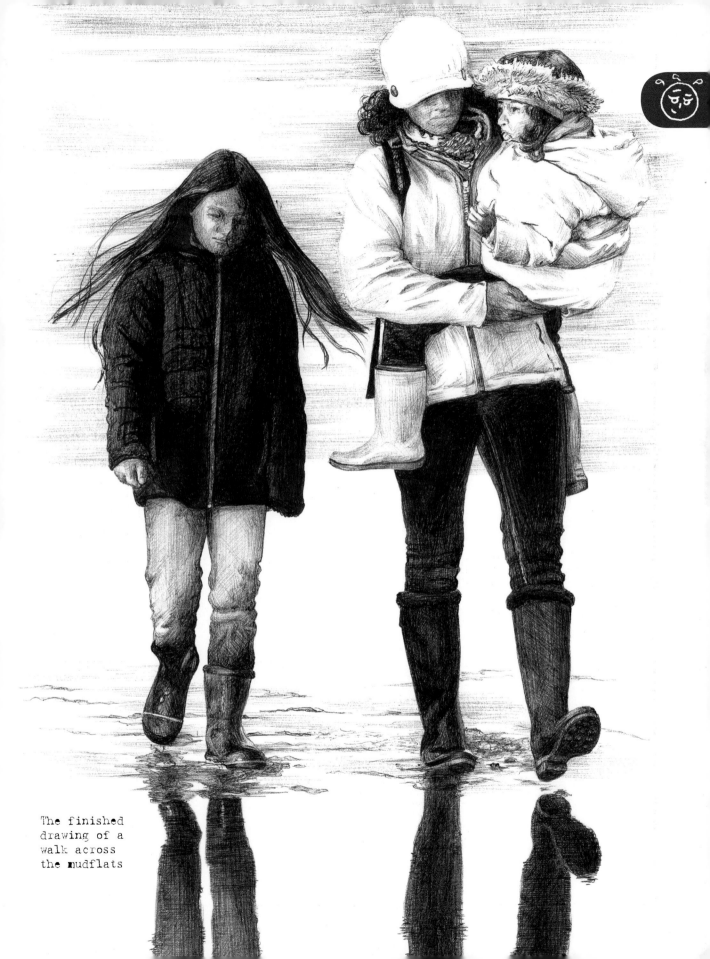

The finished
drawing of a
walk across
the mudflats

About the Author

"It is fun to always try out new things,"
says Gecko Keck (actual name Gerhard Wörner)
about himself. He also lives by that motto.
Illustrator, painter, author, designer, publisher,
entrepreneur, caterer, and organizer are just some
of the jobs which the Stuttgart native has held
over the years.

Working for more than ten years as a toy
designer for Ferrero Kinder Surprise Eggs, for
the past eight years he has been the author
of more than twenty-five books which were
translated into various languages, and took on an
ambitious entrepreneurial project with high-quality
merchandise for his second home, the Tuscan
island of Elba. These are just a few projects which
highlight the diverse creative accomplishments
of Gecko Keck. All of his experience from these
various fields influenced this book.